VERMEER AND MUSIC

THE ART OF
LOVE AND LEISURE

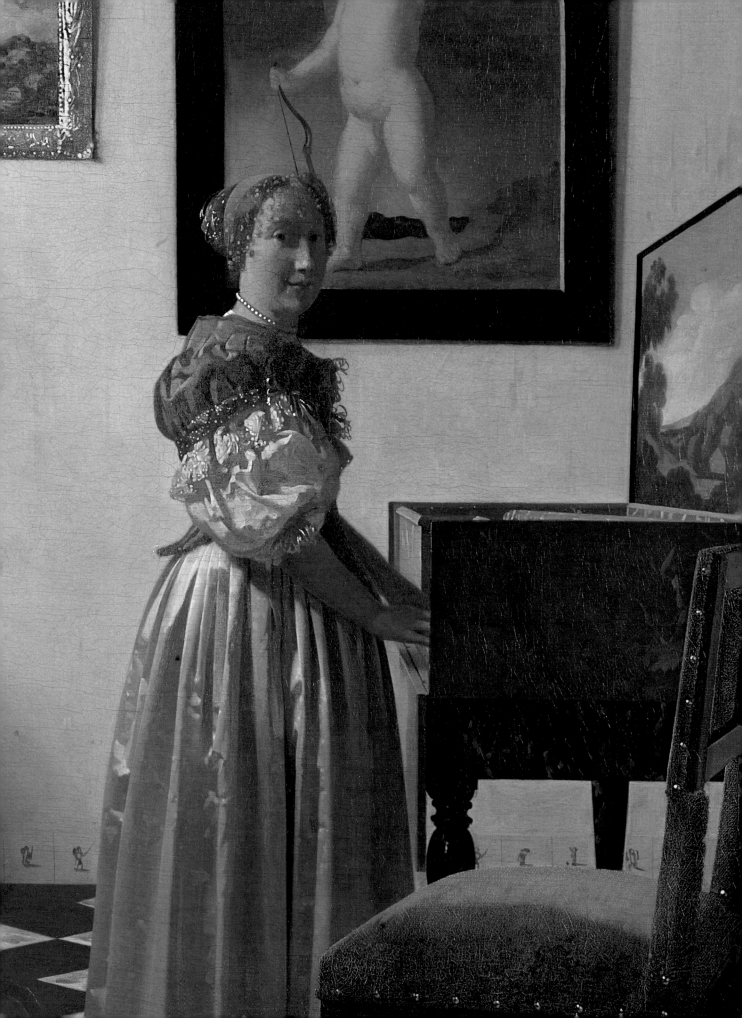

Vermeer and Music

The Art of
Love and Leisure

MARJORIE E. WIESEMAN

National Gallery Company, London

DISTRIBUTED BY YALE UNIVERSITY PRESS

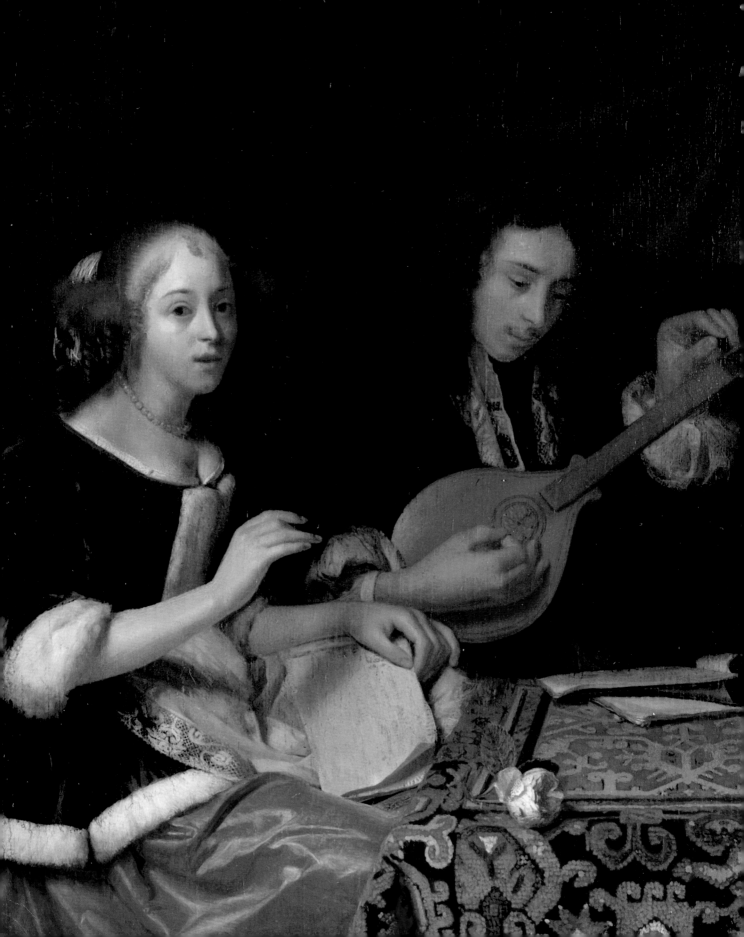

Contents

Director's Foreword

THE NATIONAL GALLERY is extremely fortunate to have in its collection two paintings by the Dutch master Johannes Vermeer. Although acquired separately by the Gallery, both represent variations on a theme popular with Vermeer and his contemporaries: music. When, in June 2012, the National Gallery became the temporary custodian of a third Vermeer with a musical subject – *The Guitar Player*, on exceptional loan from the Iveagh Bequest, Kenwood House – we felt the timing was right to stage an exhibition on the significance of music in Dutch painting. It is a subject well represented in the National Gallery, thanks to the interest of nineteenth-century collectors in these genre paintings. But we are especially delighted to bring together a total of five paintings by Vermeer, a significant proportion of his small surviving oeuvre.

Art and music have enjoyed a long relationship at the National Gallery. Music has been performed here since 1922. Lunchtime recitals, led by the internationally acclaimed pianist Myra Hess, enriched the lives of Londoners during the Second World War, while the Gallery still holds weekly concerts as part of the Belle Shenkman Music Programme. Displaying musical instruments together with paintings representing musical performance (or rehearsals and lessons) is, however, a new idea. The decision to do so allows us to appreciate the extraordinary beauty and craftsmanship of these objects, many of which actually incorporated paintings and sculptures, as well as the paintings in which similar instruments are portrayed.

The National Gallery is deeply grateful to our lenders and supporters, both public and private. We are especially indebted to the Hata Stichting Foundation, the Blavatnik Family Foundation, and Susan and John Singer; and to the Royal Collection Trust, on behalf of Her Majesty The Queen, for generously loaning *The Music Lesson*. The support of the Embassy of the Kingdom of the Netherlands has also helped make it possible to bring together a remarkable selection of paintings, instruments and songbooks.

NICHOLAS PENNY
Director, The National Gallery

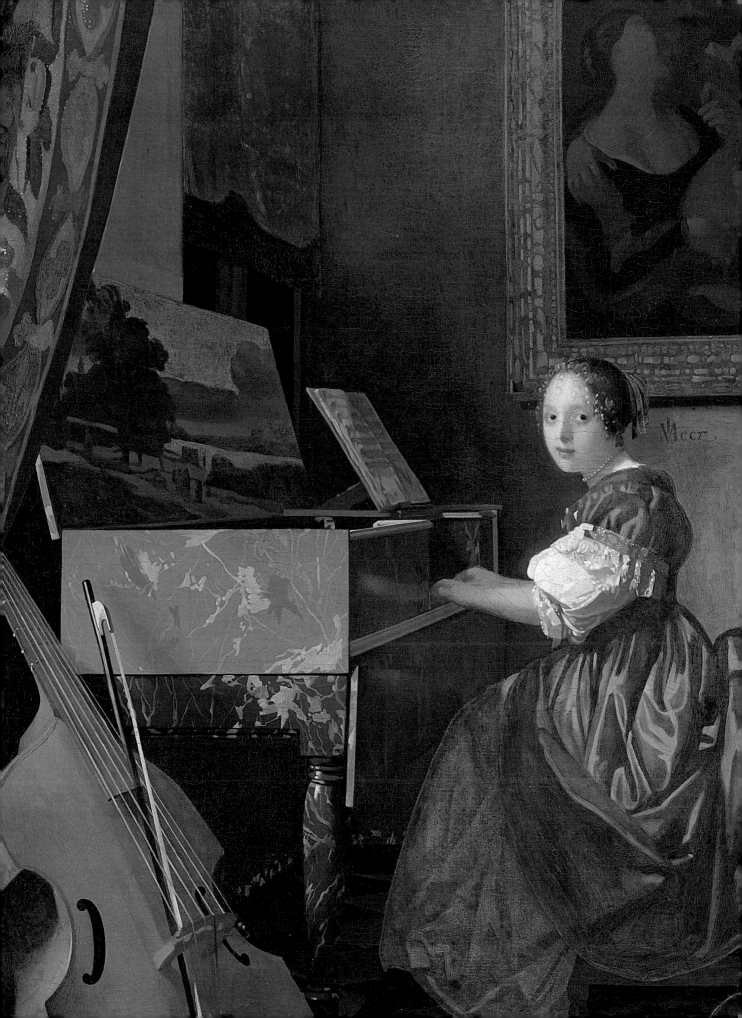

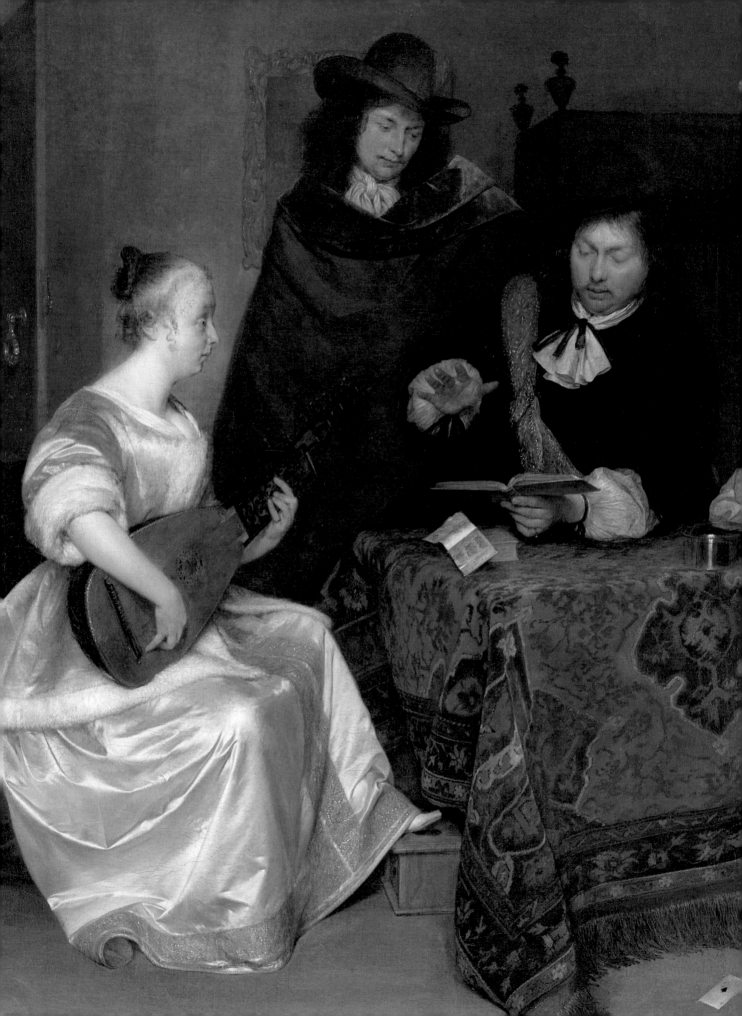

Vermeer and Music

The Art of Love and Leisure

FESTIVE GATHERINGS and rowdy celebrations, tender intimations of love and solitary reveries: many of the most characteristic images of the Dutch Golden Age revolve around music. By some estimates, musical subjects comprise as much as 12 per cent of all paintings made in the Dutch Republic during the seventeenth century, and among some genre painters (artists who created plausible scenes of everyday life), the number rises as high as 30 per cent. Of the 36 surviving paintings by the Delft painter Johannes Vermeer (1632–1675), for example, 12 depict musical themes or include a musical instrument. Early in his career, Vermeer painted a lusty brothel scene with a man (possibly a self portrait) holding a musical instrument, a scene that recalls traditional depictions of the biblical story of the Prodigal Son squandering his resources in wine, women and song (fig. 1). Within a few years, however, Vermeer's interest had shifted to depicting elegant men and women in refined surroundings. With trademark subtlety and sensitivity, he conscripted

the emotional power of music to convey the politely restrained, yet intensely felt, passions of his protagonists. Two of these evocative musical paintings are today in the National Gallery (cats 22, 23).

What inspired such an enthusiastic exploration of musical themes in paintings by Vermeer and his contemporaries? Music of all sorts permeated the Dutch Republic in the seventeenth century, and had a distinctively bourgeois character quite different to the hierarchical nature of musical life in other European countries. But it was not merely music's ubiquity that spurred Dutch artists to create these delightful images: intrigued by the challenge of expressing one sensory experience (hearing) by means of another (sight), artists sought to equal or even surpass music's harmonic, melodic and lyrical delights with visual evocations of its aural sensations and the tactile pleasures of performance. When advising young artists on how to arrange figures in a composition, the seventeenth-century Dutch painter and theorist Karel van Mander urged them to think in musical terms: 'Just as in music the multifarious sounds of the singers and the players harmonise, so here too [namely in painting] do the many different figures'. This short book highlights key aspects of musical culture in the Dutch Republic in the seventeenth century and their relationship to (and impact upon) the visual arts. Most examples are drawn from the National Gallery's superb holdings of Dutch genre paintings, offering a lively introduction to the theme.

SOME HISTORICAL BACKGROUND

In the fifteenth century, musical culture in the Netherlands was at a high. The vibrant court of the dukes of Burgundy (a territory encompassing parts of modern-day France, Belgium and the Netherlands) attracted musicians and composers of wide repute such as Guillaume Du Fay (1397–1474), Johannes Ockeghem (1410/1425–1497), Jacob Obrecht (1457/8–1505) and Josquin des Prez (about 1450–1521). The intricate and innovative polyphonic vocal compositions (involving two or more relatively independent melodic lines), both sacred and secular, that emerged from this fertile environment influenced musical developments throughout Europe.

This flowering was not to last, however. Due to political and religious upheavals, by the end of the sixteenth century, the situation had changed dramatically. From the 1560s the northern provinces of the Netherlands sought independence from the Catholic Habsburg Southern Netherlands and eventually formed the United Provinces of the Netherlands, a republic governed not by a monarch but by a stadholder (governor) and an elected body of representatives, the States General. Although they were devoted patrons of the visual arts, the stadholders in The Hague do not appear to have been very musical and consequently their court offered little

FIG. 2
Pieter Saenredam (1597–1665),
The Interior of the Grote Kerk at Haarlem,
1636–7. Oil on oak, 59.5 × 81.7 cm.
The National Gallery,
London (NG 2531)

encouragement for musicians. Moreover, in the 1570s most cities in
the Dutch Republic converted to Calvinism, forfeiting much of the rich
musical culture of the Catholic church. Strict Calvinists associated musical
instruments with idolatry and worldly excess, and considered them in
violation of the Ten Commandments' interdiction against graven images,
as well as of their own insistence on simple, unpretentious congregational
worship (fig. 2). Although organs in the newly Protestant churches
continued to be used for public concerts, and were played before and after
religious services, until the mid-seventeenth century playing instrumental
music during the service itself was strictly banned. Only unaccompanied
congregational singing was allowed. In 1641, Constantijn Huygens
(secretary to three stadholders, and a passionate amateur musician; see
cat. 7) wrote a tract arguing for the return of organs to divine service, citing
the both appalling nature of unaccompanied congregational singing and
the illogic of playing the organ for the entertainment of congregants
before and after – but not during – worship.

Without the patronage traditionally offered by a monarch or a powerful
religious body, there was little incentive for major artistic innovation by
musicians in the Dutch Republic compared with other European countries.

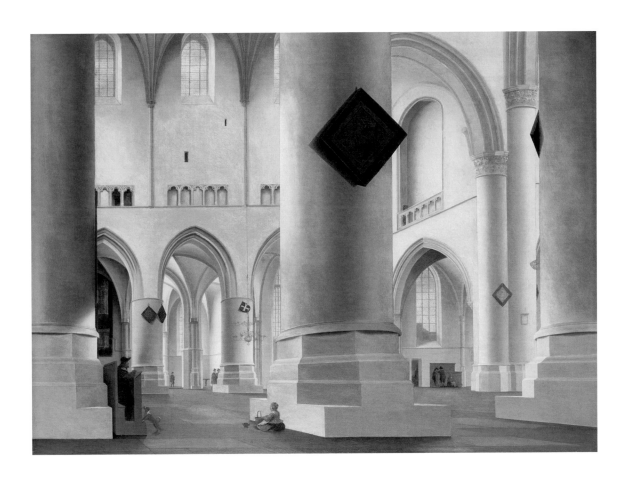

Indeed, with the exception of Jan Pietersz. Sweelinck (1562–1621), surprisingly few seventeenth-century Dutch composers achieved international stature. Dutch music of the period has been characterised as 'thoroughly bourgeois': an indigenous song culture in which traditional psalms and popular tunes predominated, with more sophisticated compositions mostly imported from other European countries.

To some extent this situation parallels developments in the visual arts. It can be argued that the strength of Dutch art lies in its remarkably naturalistic landscapes, marines, still lifes, portraits and genre paintings, and not grandiose historical pieces. Similarly, the strength of Dutch music lies not in intricate Baroque and polyphonic compositions but in simple songs, widely disseminated and performed with heartfelt enjoyment by people of all classes.

PUBLIC PERFORMANCE

Many types of music were freely available in the seventeenth-century Dutch Republic. Most towns employed city musicians, who performed at weddings, banquets, processions, fairs, and other civic events; in larger cities they might also play a daily musical interlude from the town hall or the square below. Shawms, trumpets, horns and other loud, sonorous wind instruments, together with drums, were used for open-air performances, while more intimate indoor occasions called for softer instruments such as recorders, viols or virginals (see Glossary). Ringing out from church and civic towers, carillons were – and are today – a distinctive feature of nearly every Dutch city. Carillons consist of 23 or more stationary cast-bronze bells, which are struck by clappers connected by wires to a keyboard-like console. The most famous bell casters, François (about 1609–1667) and Pieter (1619–1680) Hemony, produced over 50 carillons for towns throughout the Netherlands. The quality and meticulous harmonic tuning of their bells greatly enhanced the carillon's status as a fully fledged musical instrument. Municipally appointed city organists gave concerts on church organs, and also fulfilled other roles. For example, in addition to twice-daily concerts on the organ in Amsterdam's Oude Kerk, the composer Sweelinck gave organ and harpsichord lessons to both amateurs and professionals. Civic organ concerts may not have been provided solely for public entertainment: a document of 1593 from Leiden stated that concerts given on church organs were intended 'to keep people out of the inns and taverns in order to prevent quarrels and dissension among them'.

Those same inns and taverns were another popular source of musical entertainment, albeit one generally frowned on by church and civic authorities. Music of a sort could be found in even the roughest establishments, but *danscamers* and *musiekherbergen* (dance halls and music halls) provided more specialised offerings. On ordinary weekdays, taverns might host

FIG. 3

Jan Steen (1626–1679),
*The Egg Dance: Peasants Merrymaking
in an Inn*, 1670s?. Oil on canvas,
110 × 135 cm. Apsley House, London
(WM 1507-1948)

travelling musicians who performed popular songs to the raucous accompaniment of hurdy-gurdy, fiddle, bagpipe and rommelpot (fig. 3 and Glossary). More accomplished musicians (often moonlighting city musicians) were hired for weddings, festivals and other special occasions. Music in taverns was often intentionally loud to entice would-be customers inside. Predictably, this led to complaints and civic ordnances that attempted to prohibit the playing of loud music between sundown and sun up, whether indoors or out. Whether they played in rude taverns or more salubrious surroundings, career musicians were generally considered 'outsiders', with a low social status on a par with that of itinerant actors.

Danscamers often doubled as brothels, yet they were a perfectly acceptable outing for the elite (even women) as long as they did not consort with the whores. Musical entertainment in the *danscamers* might be provided by a solo player, duet or trio featuring a violin, a bass instrument, and a keyboard, dulcimer or small organ. One of the attractions of the *muziekherbergen*, on the other hand, was that customers were actively encouraged to take up one of the instruments lying around and participate in the performance. In fact, a sign posted in one such establishment declared that 'Anyone who can play the violin or bass or some other instrument yet does not perform a tune, must suffer a punishment from which his only release is a jug of bottle-beer or wine'.

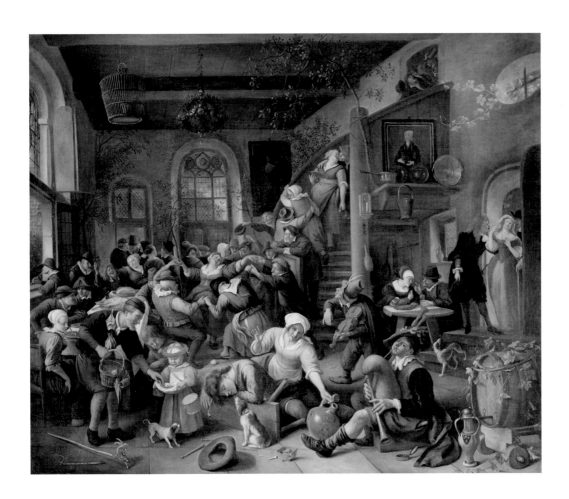

FIG. 4
Joost Cornelisz. Droochsloot (1586–
1666), *Interior with Musical Company*,
1645. Oil on canvas, 98.5 × 127.9 cm.
Collection Centraal Museum,
Utrecht (15950)

To satisfy more sophisticated tastes, many cities boasted musical
organisations known as *collegia musica* (amateur ensembles of wealthy
burghers), which practised 'serious' music such as Italian madrigals,
Latin motets, or French polyphonic *chansons* – and only rarely Dutch com-
positions – under the guidance and tutelage of a professional musician,
often the city organist (fig. 4). Members met in the home of one of
the group, or in a room made available by the city, perhaps once or twice
a week. These gatherings gradually became more public, and were a spring-
board for the development of public concerts in the eighteenth century.

By and large, music in the seventeenth-century Dutch Republic was
an active and not a passive experience: a 'concert' did not indicate static
listening in a large hall, but active participation in the communal act of
making music, usually in a domestic environment. In all its manifestations,
music was one of the most popular forms of relaxation and social
interaction throughout the period.

MUSIC AT HOME

Although music permeated public life in the Dutch Republic, most music
was to be found within the privacy of the home. Alongside written records,
paintings and prints give us a glimpse of this world, even if they cannot be
considered completely factual or objective. Holidays and family celebrations
typically involved enthusiastic singing of traditional songs, with children
often rewarded for their performances with coins or sweets (fig. 5). Music
and dance lessons were a regular part of the education of well-to-do children
and young adults. In women especially, competent (but always modest,

FIG. 5
Jan Steen (1626–1679),
Twelfth Night, 1668. Oil on canvas,
82 × 107.5 cm. Museumslandschaft
Hessen Kassel, Gemäldegalerie
Alte Meister (GK 296)

never virtuosic) musical performance was an attractive and highly
desirable trait. Versatility, and the ability to switch from one instrument
to another as needed, was valued over professional-level mastery of a single
instrument, so men and women often played more than one instrument.
The gifted amateur musician Constantijn Huygens (see cat. 7) described
his musical education at length in his autobiography. From the age of
five he received singing lessons from his own father, as well as dancing
lessons to achieve physical grace and an elegant posture. At the age of
six he learned to play the viola da gamba, or 'English viol', followed by
the lute and the *clavicimbel* (either the virginal or the harpsichord; the
term was used to refer to any plucked keyboard instrument). As an adult,
Huygens learned to play the theorbo and the guitar, and composed
nearly 800 tunes, only a handful of which survive.

Not only was music an enjoyable way to spend time with family and
friends, but well-to-do burghers often used musical encounters as a means
of expressing status, and as a vehicle for building and maintaining social
and professional ties. It is not always easy to distinguish purely social
friendships from professional relationships, but clearly music offered an

ideal entrée for cementing diplomatic and political contacts: the musical interests Huygens shared with Louise de Coligny (1555–1620), mother of the future stadholder Frederik Hendrik (1584–1647), for example, were probably instrumental in his later winning an appointment as secretary to the stadholder. As Huygens noted, 'I consider it to be one of the chief fruits of my music making (which my father with his far-sightedness well understood) that I have thereby won the sympathy of a great many people'.

The Antwerp banker and collector Diego Duarte (about 1610 – after 1691), who may have owned one of the two Vermeer paintings in the National Gallery (see cat. 22), came from an extraordinarily musical and well-connected family (fig. 6). Visitors to the Duarte home, both friends (Huygens among them) and business and diplomatic contacts, were regularly treated to family concerts: Duarte senior and the three Duarte sisters offered guests 'a fine consort and harmony for luts, viols, virginals and voyces'. One visitor commented that he had scarcely heard better music at the home of the renowned composer Claudio Monteverdi in Venice. While all in the family were accomplished musicians, it seems that Diego and his brother did not play before guests. As gentlemen of a certain social

FIG. 6

Gonzales Coques (1614/18–1684), *Portrait of a Family of Musicians, thought to be the Duarte Family*, about 1644. Oil on canvas, 65.8 × 89.5 cm. Szépmüészéti Múzeum, Budapest, Esterházy Collection, 1871 (573)

Vermeer and Music

class, they did not wish to be taken for full-time musicians: not only did musicians hold a lower social status, but excessive proficiency on an instrument might arouse suspicion that more important matters had been neglected in its pursuit. There would be no such confusion with women performing in a domestic arena, however, as they were not expected to engage with 'serious' affairs.

Amateur musicians like Huygens and Duarte not only used music to facilitate professional advancement, but, conversely, used their extensive international contacts to feed their musical interests: sharing experiences, soliciting advice or asking for help in procuring instruments and music from distant places.

INSTRUMENTS AND COLLECTIONS

Avid musicians often amassed impressive collections, the size and scope of which might seem surprising to us today. Obviously, having a selection of instruments close to hand would tend to encourage spontaneous musical gatherings. Among the wealthy bourgeoisie, stringed instruments (both plucked and bowed) and keyboards were the most popular for solo and ensemble playing: these are the instruments we see depicted most often in genre paintings of the seventeenth century, and these are the instruments for which the largest repertoire survives. One of the key features of music in the Baroque era was the *basso continuo*, the practice of improvising a chordal or melodic accompaniment above a composed bass line. For this reason, instruments that provided the bass line – such as the viola da gamba (bass viol), theorbo, lute or keyboard – were the cornerstone of ensemble playing. Elegant domestic ensembles might include one or more singers accompanied by a stringed instrument such as a lute, theorbo, viol or keyboard (virginal or harpsichord), or a combination of these instruments. Citterns, and later in the century, guitars, were also popular. On the other hand, elite players often considered flutes, recorders, bagpipes and other wind instruments (fig. 7) undignified, in part because blowing into them distorted the face in an unseemly manner; even Plato had advised against teaching children to play wind instruments, because of their 'wide range and ecstatic effect'.

The impressive (and costly) collection of instruments formed by Constantijn Huygens featured multiple lutes, theorbos and viols, and at least one violin, as well as several virginals, harpsichords and organs. Huygens also assembled a vast library of printed and manuscript music and books and manuscripts on music theory. His voluminous correspondence confirms that he used his extensive network of international contacts to locate and acquire exceptional instruments, by renowned makers. For example, in 1638 he consulted Nicholas Lanier, foremost musician at the court of Charles I, for advice in purchasing from London

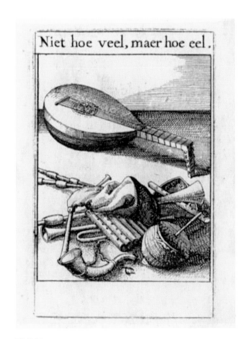

FIG. 7
Claes Jansz. Visscher (1587–1652),
'Niet hoe veel, maer hoe eel' ('Not
how many, but how well') illustration
from *Sinnepoppen (Emblems)*, 1614
(p. 21), written by Roemer Visscher
(1547–1620).
Private Collection

a 'consort [ensemble] of six old viols, but the most excellent one could possibly find'. A decade later, with the assistance and advice of Diego Duarte, Huygens acquired a harpsichord built by the Antwerp maker Jacques Couchet, which had 'a very sweet and lovely harmony, and has been much praised by all the music lovers'.

Although instrument makers could be found in larger cities throughout the Netherlands – shawms, recorders, violins, viols, citterns, lutes and keyboards were among the instruments produced locally (fig. 9) – many, like Huygens, preferred to import instruments from more specialised centres across Europe. Keyboards from the Southern Netherlands (particularly Antwerp, see fig. 13), lutes and citterns from Italy or the Germanic lands (figs. 8 and 12), viols from England (fig. 10)

FIG. 8
Lute, by unknown maker, about 1630, Venice. Pine, ivory, and ebony, 82 cm (overall length). Victoria and Albert Museum, London (1125-1869)

This eleven-course lute has been little altered since its creation. It may have served as an artist's prop (rather than a professional musician's instrument) after the early 1800s, otherwise it would likely have been modified or had parts replaced. The use of ebony and ivory, and the lavish decoration, are typical of instruments produced in Venice between about 1630 and 1650.

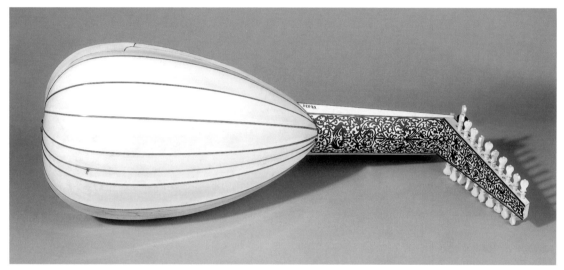

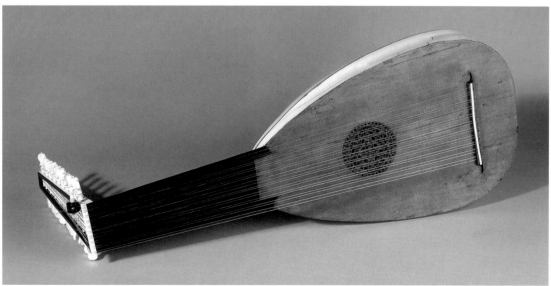

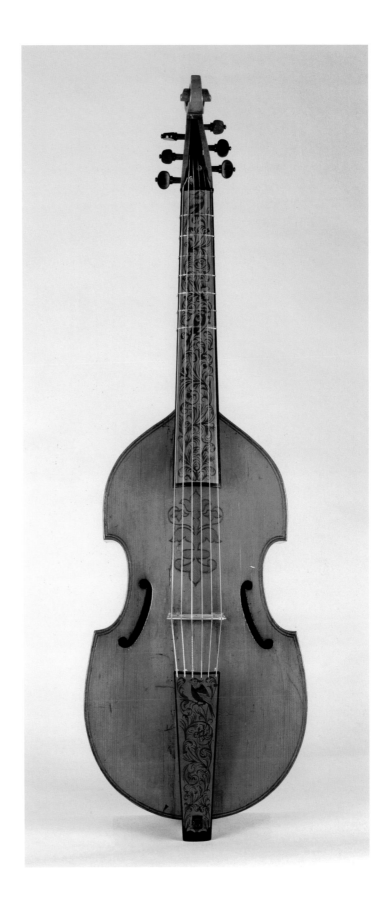

FIG. 9 (*above*)
Violin, by Hendrik Jacobs (1629/30–1704), about 1690,
Amsterdam. Maple, spruce, and whalebone,
35.3 cm (body length). On loan courtesy of the
Royal Academy of Music Museum and Collections,
London (2002.389)

Hendrik Jacobs was one of the earliest and most
famous violin makers in Amsterdam. The design and
construction of his violins was inspired by instruments
produced by the renowned Amati family of Cremona.

FIG. 10 (*right*)
Viol, by Barak Norman (before 1670–about 1740), 1692,
London. Maple and conifer, 118.6 cm (overall length).
Royal College of Music, London (RCM 46)

Barak Norman was one of the best-known English
makers of viols and violins. The intricate decorations
on this instrument include a stylised tulip motif on
the body, and marquetry inlay on the fingerboard
and tailpiece. English viols were highly regarded
on the Continent and routinely exported to the
Low Countries.

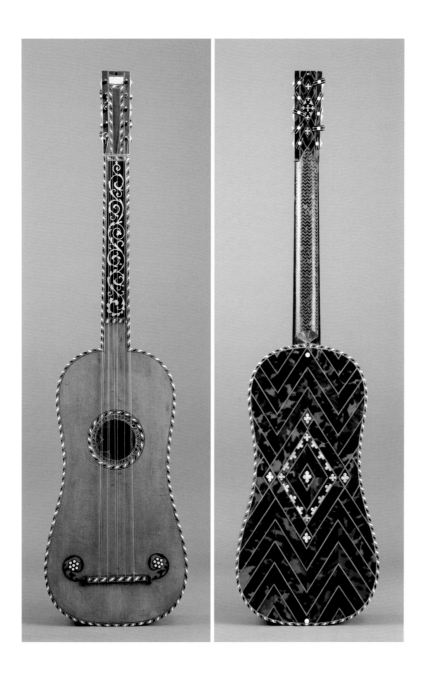

FIG. 11 (*left*)
Guitar, by René Voboam
(before 1606–before 1671),
1641, Paris. Pine or spruce,
tortoiseshell, mother-of-pearl, ivory and
ebony, 93.7 cm (overall length). Ashmolean
Museum, Oxford (WA1939.36)

This guitar is decorated with a striking
combination of ivory, ebony, tortoiseshell
and mother-of-pearl. The soundhole rose is
made of multiple layers of ornately scrolled
paper. René Voboam was the founder of an
esteemed dynasty of French guitar makers.

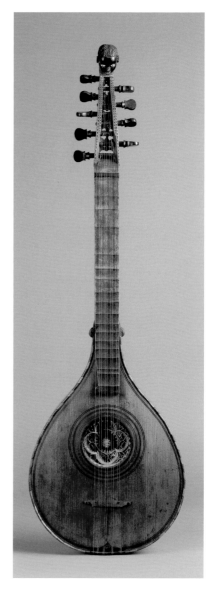

and guitars from France and Spain were all keenly sought in the Dutch
Republic (fig. 11). Among the most popular (and expensive) imported
instruments were virginals and harpsichords built by the Ruckers family
of Antwerp: one of their virginals might cost the equivalent of a skilled
worker's wages for a year (fig. 13). Costly Ruckers-like keyboards appear
in elegant genre paintings by Vermeer, Steen, Metsu and other artists
(cats 9, 16, 21, 22, 23 and 25). While quality of sound is independent of
external appearance, the finest instruments were often enhanced with
elaborate incised or applied ornamentation and the use of expensive
materials such as ivory, mother-of-pearl, tortoiseshell and exotic woods.

FIG. 12 (*below left*)
Cittern, by unknown maker, early eighteenth century, Italy. Spruce, maple, metal, ebony, ivory or bone, ink, pigment and gilding, 76 cm (overall length). Ashmolean Museum, Oxford (WA1948.134)

The shallow, pear-shaped body is typical of Italian citterns. The neck is fretted with metal bars; the top of the pegbox is ornamented with a carved African boy's head. Ebony pegs carry five courses of strings, four of which are double.

FIG. 13 (*below*)
Virginal, by Andreas Ruckers I (1579–1651/3), 1640, Antwerp. Wood and paper, 150 × 49 × 23 cm (instrument), 106 × 42.5 × 78 cm (stand). Rijksmuseum, Amsterdam (on loan from the Koninklijk Oudheidkundig Genootschap, BK-KOG-595)

This virginal is of the muselar type, with the keyboard situated to the right of centre. The delicate arabesque pattern of the block-printed paper decorating the front of the instrument is similar to that seen on instruments in paintings by Steen, Vermeer and others (cats 16, 21). The inscription on the lid reads: MUSICA LABORUM DULCE LEVAMEN (Music is the sweet solace of labour).

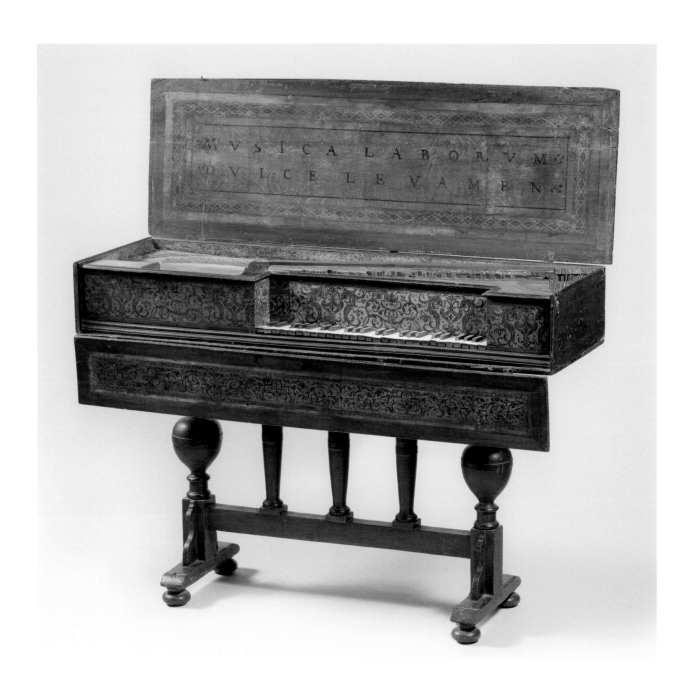

The lids of keyboard instruments were often painted with landscapes or other pleasant scenes, sometimes by well-known artists, which could add considerably to the cost of the instrument. Alternatively, lids or interiors (or both) might feature improving, didactic or religious Latin mottos, presumably chosen to counteract any possible temptations incited by the music (cats 9, 16, 21).

MUSIC AND SONGBOOKS

Whether sacred or secular, Dutch music of the seventeenth century was dominated by songs: simple, catchy and enormously popular. How were the songs disseminated? Oral tradition was strong, and it was also common practice for friends to exchange printed or manuscript music, even internationally, which the recipient would then copy and return. During the course of the seventeenth century, Amsterdam became a centre for music publishing, producing printed music to suit nearly every purse: from inexpensive song sheets hawked on street corners to deluxe music- and songbooks purveyed by publishers and specialist booksellers.

It is important to distinguish between two common types of musical publication: music books (printed scores, or tablature) and songbooks. Both were aimed primarily at amateurs with relatively little musical training, as full-time musicians were not only notoriously impecunious, but of necessity skilled mimics, adept at improvising and devising harmonies on the spot. Many music books contained ensemble music with melodic, bass, and harmony parts that could – depending on the instruments and players available – be performed using various combinations of instruments. Simplified adaptations of dance tunes were particularly popular, for accompanying dances among small circles of friends and family.

Unique among European countries, the Dutch eagerly embraced the printed songbook and developed it into a fine art. Described as 'a portable pharmacy for the soul', songbooks offered a selection of tunes designed to encourage love or soothe its pangs, dispel melancholy, or bring inner peace. The most deluxe publications featured varied typography and attractive layouts interspersed with engraved illustrations by well-known artists (fig. 14). Expensive volumes costing one or two guilders were often reissued in cheaper editions, costing just a few pennies, for a wider audience. The majority of songbooks contained text but no musical notation, just a brief indication of the tune to which they should be sung, typically traditional folk melodies or tunes imported from other countries. Verses could be sung to different tunes, and a single tune could host any number of lyrics. There was lively competition among publishers to include the newest verses, which ranged from poems by some of the most famous writers of the day, to amusingly vulgar rhymes and verses with strong local appeal that referenced area attractions or popular pastimes. These were the

FIG. 14
Den nieuwen verbeterden Lust-Hof
(*The New Improved Pleasure-Garden*),
1607 (title page and p. 45), by Michiel
Vlacq. The British Library, London
(BL 11555.ee.22)

Lust-hof/ Gheplant vol uytgelesene/eer=

lijcke/Amozeuse ende vzolijcke ghesanghen/als Mey/Bzuylofts/Tafel/ende Nieu
jaers-liedekens/ met noch verschepden tsamen-spzeeckinghen tusschen Vzyer en Vzyster.

Verciert met seeckere Copere Figueren die opte Liedekens accozderen.

Item is noch hier achter tot een besluyt by ghevoeght/ een Bruylofts Bancket, verciert met
dan met stichtelijcke Tafel ende Bzuylofts Liedekens: alles op goede mate ende
voysen ghestelt van verscheyden experte Componisten/noyt te vozen ghedruckt.

Den derden druck gebetert en veel vermeerdert.

t'Amstelredam, by Dirck Pietersz, in die witte Persse by die oude Brugge aent VVater, Anno 1607.

Nieu liedeken op de voys, ghelijck het selfs begint,
En diese niet en weet,magh sien dat hyse vint.

Vryer.

Esen Beker die ick houx
Jonckvrou wilt die wachten//wel

Vryster.

Dat ick sulcks niet vozen woude
Sout ghy my verachten snel?
Vry. Nem ick Lief tot gheenen tijt/
Vryst. Ghy toont Jonghman wat ghy zijt
vry. O dienaer?
vryst. Nem voorwaer
vry. Mocht het wesen/
vryst. 't Sou u selver qualen swaer.
vry. Saeght ghy lief mijn treurich herte
Hoet om u in pijne//is/
vryst. Lustigh Jonghman hebdy smerte
soeckt u medecijne//fris/
vry. Lief ghy kont dit doen naest God/
vryst. Jonghman drijst met my gheen spot
vry. 't Waer my leet/
vryst. Doet gheen eet/

E 3 Sulcks

pop songs of the day: songs about love, drinking, sex, comic and satirical stories and, on occasion, even religious themes. Songs for a single voice were the most prevalent, sometimes accompanied by virginal, lute, cittern or other instruments.

Predictably, the most popular songs dealt with love in all its guises, and the most charming songbooks were those marketed to young adults enraptured by love's capricious triumphs and travails. Love songs provided entertainment and opportunity for romantic interaction, but also offered consolation in the event of disappointment. Illustrated songbooks were popular gifts from a young man to his sweetheart; most were quite small – about 12 by 18 centimetres, or even smaller – and could be easily carried in a pocket or hidden from disapproving elders. Publishers quickly realised the commercial potential in the songbook's appeal as an intimate, erotic and eminently portable love-token. Some included a sentimental dedication page, with a space left blank for the suitor to personalise it with his beloved's name. The introduction to a songbook published in 1616 describes a suitor's envy of the physical intimacy enjoyed by his paper surrogate: 'Go hence, lucky book, in those snow-white hands/And in that sweet lap, the fairest in the land,/Go hence melodiously: and let yourself be sung by the one/Who has my heart and senses completely in her power'.

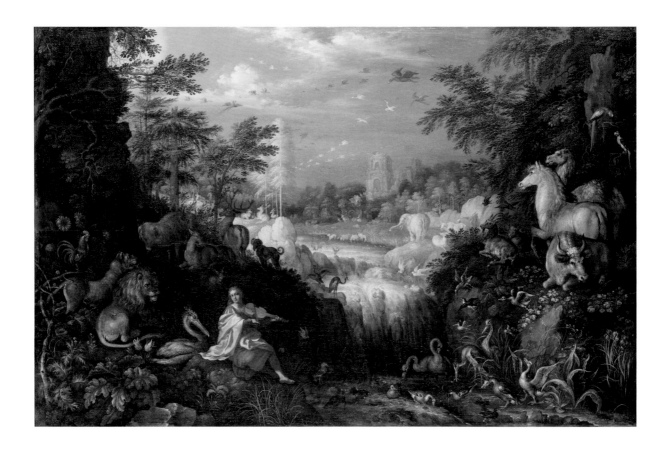

Vermeer and Music

FIG. 16

Louis Finson (1580–1617),
*The Prodigal Son (Allegory of the Five
Senses)*, about 1605. Oil on canvas,
141 × 189 cm. Herzog Anton
Ulrich-Museum Braunschweig,
Kunstmuseum des Landes
Niedersachsen (37)

MUSIC IN PAINTINGS

The accessibility and popularity of music in the Dutch Republic virtually assured its success as a motif in the visual arts, as musicians and art aficionados looked to prolong music's pleasurable, but ephemeral, sensations with more lasting visual mementos. There was a long tradition of representing musical themes in Netherlandish art that encompassed both positive and negative associations: music was usually cast as a divine gift of the gods or of God, but its inherently sensual and sensory qualities also led to its being viewed with deep suspicion, a way for sin to gain access to the unwary soul. The earliest representations of music, from the fifteenth and sixteenth centuries, tend to be allegorical or symbolic in nature: in angelic concerts; as a saintly attribute or in the hands of mythological figures such as Apollo or Orpheus (fig. 15); in representations of Hearing from allegories of the Five Senses (fig. 16); or as a symbol of harmony, temperance, or transience. The concept of harmony – whether marital or familial – was frequently expressed metaphorically through the tonal unity of a consort of instruments. For example, Jan Miense Molenaer portrayed his own extended family as an ensemble of musicians gathered before a gallery of portraits of other (deceased) family members (fig. 17). The image clearly expresses the warm and harmonious bond that united several generations of this family.

The use of musical imagery to suggest harmony between lovers was, if anything, even more popular. A popular emblem from Jacob Cats's *Sinne- en Minnebeelden* (*Images of Allegory and Love*, 1618), entitled 'Quid non sentit amor' ('Who does not feel love?'; fig. 19) depicts a man with two lutes: as he tunes one, the strings of the other begin to vibrate in unison, suggesting lovers' hearts beating in tandem. Constantijn Huygens's love poem entitled 'Two unpaired hands upon a harpsichord' (1648) likens a musical duet between a man and a woman with the harmony created in love and marriage; the same analogy inspired the double portrait of Huygens and his wife, Suzanna van Baerle, painted more than a decade earlier (fig. 18). The music sheet they share features a *basso continuo* part, perhaps suggesting a parallel between the fundamental role of the bass line in music, and the role of the husband (the bass voice) as the supposed basis of marital unity.

For all its haunting charm, music exists only in the moment, vanishing completely as the sounds themselves fade away. Coupled with motifs

FIG. 17

Jan Miense Molenaer (about 1610–1668), *Self Portrait with Family Members*, about 1635. Oil on panel, 62.3 × 81.3 cm. Frans Hals Museum, Haarlem. On long term loan from the Cultural Heritage Agency of the Netherlands (OS75.332)

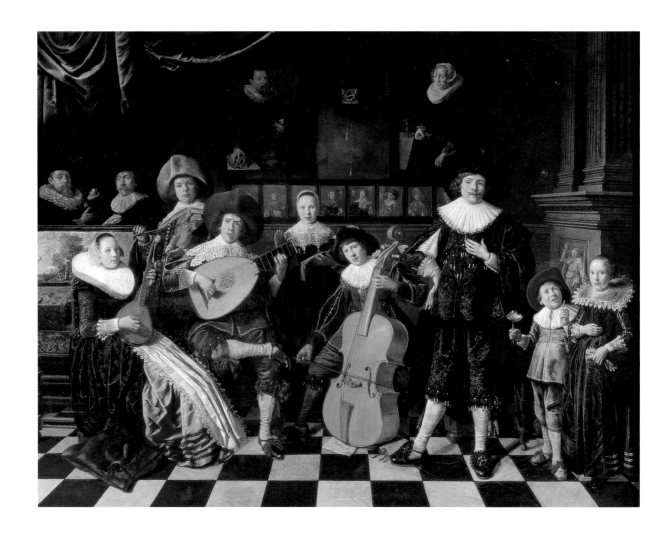

Vermeer and Music

FIG. 18

Jacob van Campen (1596–1657),
*Double Portrait of Constantijn Huygens
and Suzanna van Baerle*, about 1635.
Oil on canvas, 95 × 78.5 cm.
Royal Picture Gallery Mauritshuis,
The Hague (1089)

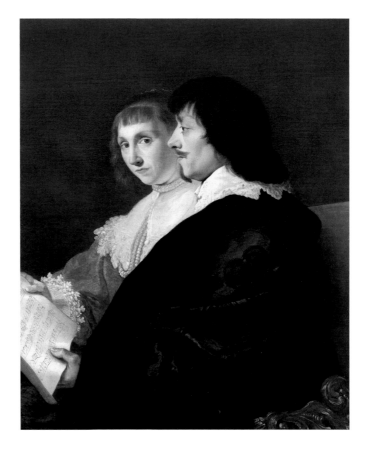

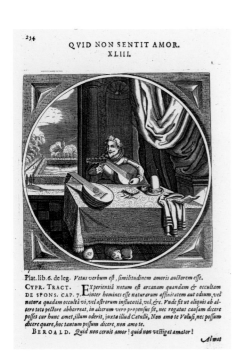

FIG. 19

'Quid non sentit amor', ('Who does
not feel love?), illustration from
*Proteus, ofte Sinne- en Minnebeelden
(Images of Allegory and Love)*, 1618,
by Jacob Cats (1577–1660),
Private Collection.

representing death and worldly vanities, music was a common symbol
of transience in literature, in didactic emblems (fig. 20), and in paintings
(see cats 5, 18, 19). Many keyboard instruments featured printed mottos
with *vanitas* themes – 'Sic transit Gloria mundi' ('Thus passes the glory of
the world'), for example – and soundboards decorated with paintings of
delicate cut flowers, tiny insects, and other short-lived creatures of nature,
to draw attention to music's ephemeral allure and sensory temptations.
Music's renowned power to dispel melancholy and soothe the soul inspired
countless images; literal statements of music's therapeutic effects were
inscribed on keyboard instruments as well (see cat. 21). Because Western
music relies so heavily on measured time, and on the specific mathematical
relationships of musical intervals, music also came to symbolise the
virtues of temperance and moderation.

In addition to these broader symbolic interpretations, individual
musical instruments were invested with associations that nonetheless
could vary considerably depending on the context. The lute, for
example, was one of the most popular instruments during the period:
the seventeenth-century composer and theorist Michael Praetorius
termed the lute *fundamentum et initium* (the foundation and beginning)
of all music. Prized for its versatility and ability to accompany the voice,

the lute appears frequently in visual imagery, where it often symbolised various aspects of harmony. In portraits the lute generally expressed harmony of a pure and elevated sort, but genre imagery – the realm of fantasy and anonymity – allowed for far more titillating associations. There, the lute was often (but not always) sexualised, played provocatively by prostitutes and introduced as a symbol for female genitalia. (For representations of lutes in various contexts, see cats 1, 2, 3, 5, 12, 14, 17 and 18; and figs 4, 7, 16, 17, 19, 20 and 21.)

FIG. 20
Theodoor Matham (about 1605–1676), *Still Life with Merry Company (Vanitas)*, 1622. Engraving, 22.9 × 33 cm. Fine Arts Museums of San Francisco, Achenbach Foundation for Graphic Arts (1963.30.13265)

SYMBOL AND REALITY

The symbolic associations of music that were established in the fifteenth and sixteenth centuries – including temperance, transience, harmony and the sense of Hearing – continued throughout the seventeenth century, as the examples described throughout this book demonstrate. However, it is not always easy to distinguish one single interpretation for the musical motifs in an image, particularly when (as can be the case with portraits, genre paintings, and some still lifes) the images do not express an identifiable narrative. For example, the inclusion of musical accessories in a portrait might indicate that the subject was a musician, but they might also have been introduced as more general indicators of a certain level of education or sophistication, or as an allusion to the virtues of temperance and moderation.

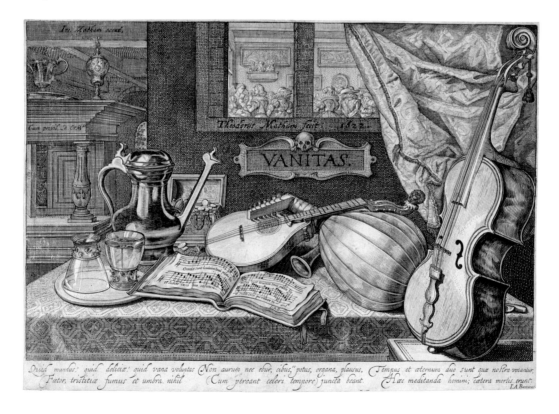

Vermeer and Music

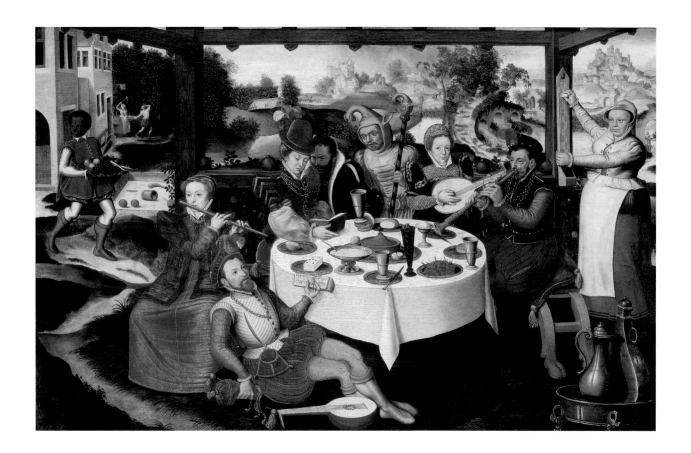

In the uniquely Dutch realm of genre painting, other priorities
eclipsed traditional symbolism as the century developed. Certainly,
many genre scenes continued to incorporate references to transience,
temperance, or harmony in either its purest forms or via rather cruder
sexual innuendos. But what became increasingly important was the
painter's ability to create a realistic evocation of the musical experience
and to involve the viewer in it, giving visual form to the music and
mimicking the participatory nature of musical performance during the
period. As one example of this evolution, the enduringly popular 'musical
company' has its formal and iconographic roots in representations of
the biblical story of the Prodigal Son, which show the youth carousing
amidst wine, women and song (fig. 21). Initially, the genre scenes drew
pointed parallels between the biblical wastrel and the excesses of Holland's
infamous 'golden youth' (the ne'er-do-well offspring of wealthy upper-class
citizens), but they gradually lose these moralistic and negative associations.
Their 'meaning' instead lies in the illusion of a plausible reality: in the
aspirational image of status and sociability they present, and in their
evocation of a remembered musical experience.

Although the Dutch Republic offered citizens a wide array of musical
experiences (organ concerts, *collegia musica*, and so on), it was the impromptu

musical activities of the wealthy bourgeoisie or the picturesque lower classes that were depicted most often in the visual arts. The extraordinary popularity of these subjects suggests that they resonated deeply with contemporary art- and music-lovers, perhaps because they provided a more vivid and more 'modern' empirical notion of music than the abstract allegorical representations of previous eras.

The challenge for the painter, of course, was how to get a mute and static image to suggest a live, audible performance. Parted lips, and upraised hands to mark the beat were one way; singers are often shown holding books of tablature (rather than songbooks, which were mostly text), to make it clear that they are 'making music'. To enhance the realism, many artists devised ways of involving the viewer in the scene: a figure's outward glance, or an empty chair or musical instrument placed prominently in the foreground, inviting the viewer to join in the concert (see, for example, cats 2, 4, 22, 23 and 25). Interestingly, despite the meticulous attention to detail that is so characteristic of Dutch genre paintings, the music sheets and songbooks appearing in the paintings are almost never fully legible or identifiable. This was undoubtedly a deliberate artistic device, one that enabled the viewer to imagine his or her favourite tune was being played by the musicians within the painting – thereby making the viewing of the picture a constantly changing and highly personal experience.

Despite their apparent verisimilitude, it is difficult to assess just how realistic seventeenth-century paintings of domestic concerts might be: like most Dutch painting of the seventeenth century, these scenes are a clever blend of fantasy and reality. For the most part, the instrumentations depicted in a given painting are plausible – one or two instruments to provide the melody, plus bass and/or harmony – and the way the instruments are held and played is reasonably accurate. However, some of what we now suppose to have been the most common sorts of ensembles, such as consorts of recorders, viols or lutes, are not represented; conversely, no repertoire exists for many of the ensembles depicted in the paintings. It may be that artists rejected common musical practice in favour of greater pictorial variety by including different instruments. The instruments themselves are sometimes subject to artistic liberties, but in other cases the accuracy of their representation provides important information about how surviving instruments might have appeared, before they were modified and modernised over the intervening centuries.

In general, women are shown playing instruments more often than men in Dutch genre paintings; indeed, harpsichords and virginals are played almost exclusively by women. This is not merely a pretty allusion to the accomplishments expected of young ladies of social standing, but perhaps also a reflection of actual practice: we have seen how, in the case of the Duarte family, the young men avoided playing before guests so there

would be no question that they might be mistaken for career musicians. While this does not imply that all male musicians depicted in genre paintings were full-time players (and therefore of dubious character), the motif of men instructing young women in the art of music (and love) inspired countless humorous and subtly provocative images (cat. 16).

The National Gallery currently houses about two dozen seventeenth-century Dutch paintings with musical subjects. Most are small-scale genre scenes depicting elegant musical companies in finely appointed interiors, reflecting the taste for exquisitely crafted images of an idealised 'Golden Age' among the nineteenth-century collectors whose gifts, bequests and scholarship helped shaped the nucleus of the Gallery's collection. The two paintings by Vermeer entered the Gallery's collection separately, but were probably conceived by the artist as variations on a single theme (cats 22, 23). Works by the Caravaggesque painter Hendrick ter Brugghen (cats 2, 3), and by the versatile Haarlem painter Jan Miense Molenaer (cats 11, 12), depict somewhat more spirited musicians, while a selection of portraits and still lifes with musical instruments illustrate a few of the many symbolic roles accorded music in the seventeenth century (cats 5, 7, 10, 18, 19). The brief commentaries that follow focus on some of the musicological aspects of these well-known paintings. Mute, but expressive, these beautiful, stilled images are a poignant echo of the rich musical life that flourished in the Dutch Republic of the seventeenth century.

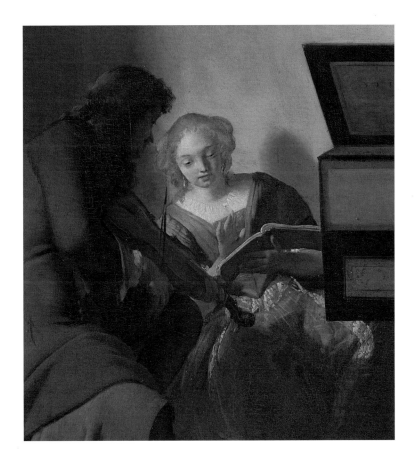

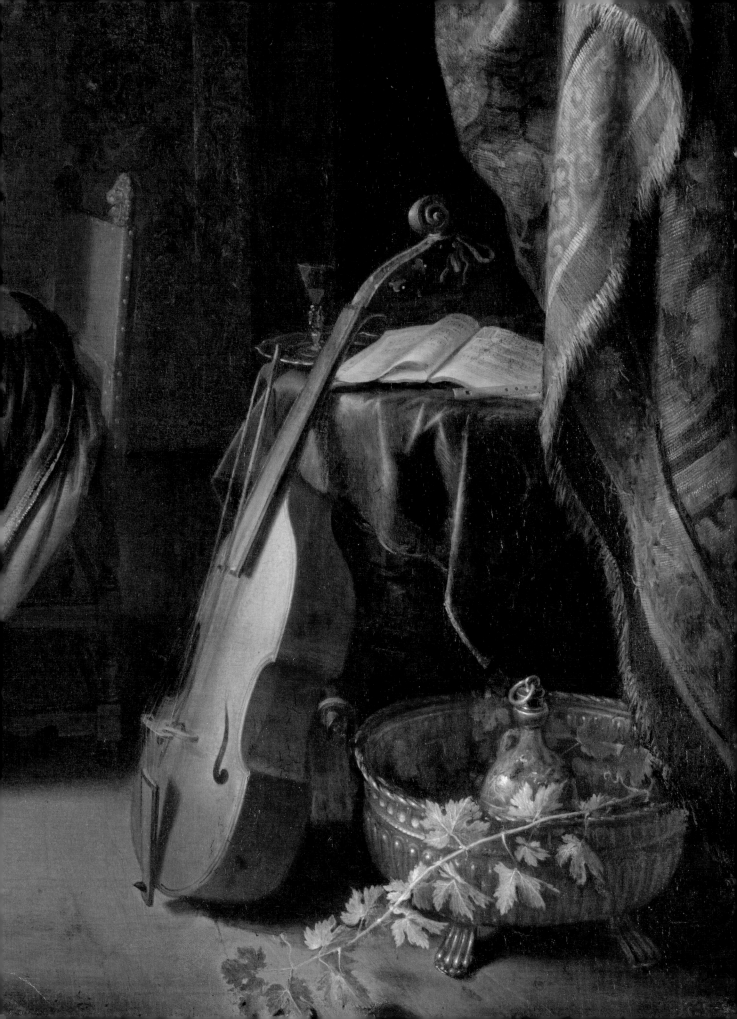

Catalogue

GERARD TER BORCH (1617–1681)

I *A Woman playing a Lute to Two Men,* about 1667–8

Oil on canvas, 67.6 × 57.8 cm
The National Gallery, London (N G 864)

Elegantly dressed in a satin skirt and fur-trimmed house
jacket, a young woman plays a two-headed 'French' lute.
The placement of her hands and her fingering suggest
she is an accomplished player. Her instrument is quite
fine: the fingerboard is ornamented with an elaborate
scrollwork design, and glistening highlights rimming the
body of the instrument suggest an inlay of mother-of-
pearl. On the table before her is a book of lute tablature.
Seated on the other side of the table is a man holding
similar book; he may be reading the same tablature
and guiding the young woman's performance with the
movements of his upraised hand. The presence of a
second man, who intently watches the gestures of the
first, introduces a note of ambiguity typical of ter Borch's
approach to subject matter, and provokes curiosity about
the figures' interpersonal relationships. Both men wear
hats, suggesting that they are visitors.

A Woman playing a Lute to Two Men, about 1667–8

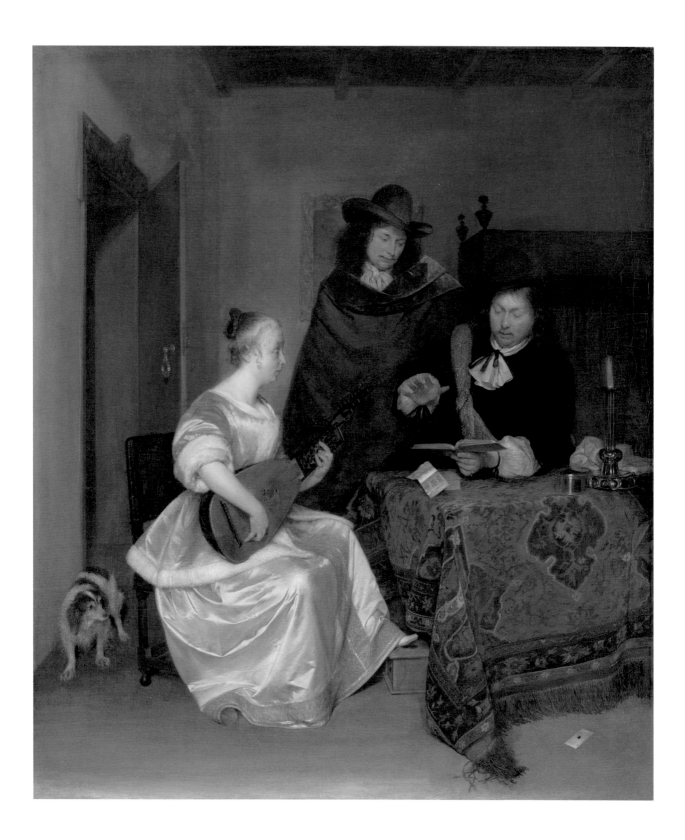

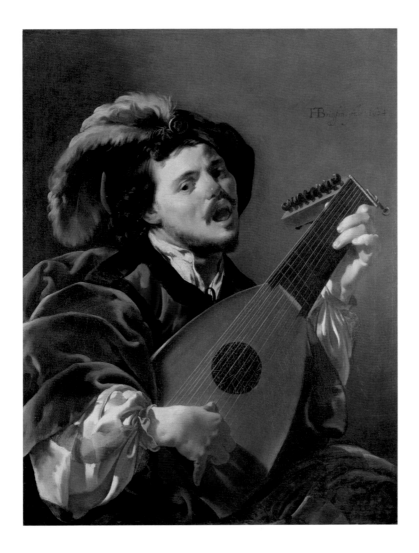

HENDRICK TER BRUGGHEN (1588–1629)

2 *A Man playing a Lute*, 1624

Oil on canvas, 100.5 × 78.7 cm
The National Gallery, London (NG 6347)

The flamboyant costume worn by ter Brugghen's lute player is a far cry from typical everyday dress in the Netherlands during the seventeenth century. In depictions of musicians and performers, such odd, colourful garments were a way of distinguishing and distancing these marginal characters from their more respectable audiences, and of hinting at their bold and unpredictable behaviour. The intensity of ter Brugghen's musician is heightened by the artist's use of strong lighting and an up-close portrayal, both features characteristic of works by the northern followers of Caravaggio. The man's opened mouth indicates that he sings as he accompanies himself on the lute. A seventeenth-century print after a similar painting by ter Brugghen is confidently inscribed, 'I play expertly on the sweet, full strings of the lute/Thereby I can also sing lustily and know that it sounds good'.

The lute itself is rendered with unusual clarity. At the top right of the fingerboard of the 10-course instrument, ter Brugghen has carefully depicted the distinctive chanterelle rider: a separate tuning peg provided for the first (highest) course on the lute, a single string known as the chanterelle. The front of the lute (the soundboard, or table) appears to be slightly concave, possibly a distortion caused by the tension of the strings.

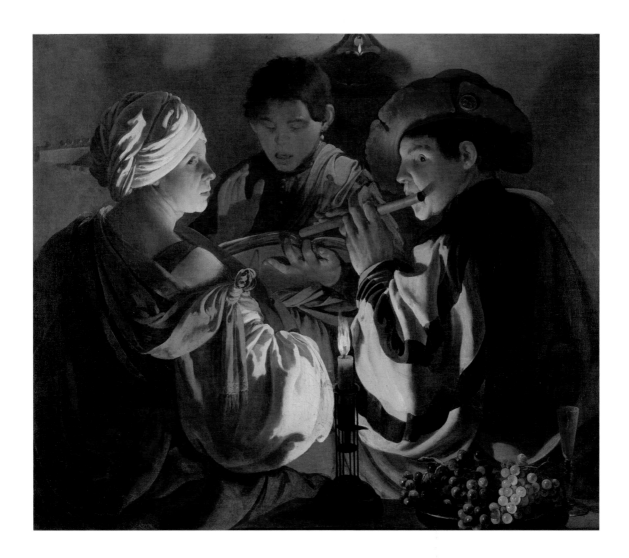

HENDRICK TER BRUGGHEN (1588–1629)

3 *The Concert*, about 1626

Oil on canvas, 99.1 × 116.8 cm
The National Gallery, London (NG 6483)

The haunting calm of ter Brugghen's trio is quite different from the extroverted gaiety shown in most concert scenes painted by the northern followers of Caravaggio. The woman at the left plays a lute; the man at right, a transverse flute. At the back of the scene, a boy holds a fairly large (music) book; his opened mouth and upraised hand suggest that he is singing and beating time. Although the two foreground figures turn and glance towards the viewer out of the corner of their eyes, they maintain an aura of privacy and neither engage with us nor invite us into the scene. In fact, their billowing sleeves and the candle between effectively block our access to the group. The grapes and glass of wine in the immediate foreground to the right have been interpreted as a reference to Bacchus, the Roman god of wine and revelry, but the painting's solemn mood is hardly that of a bacchanal. Rather, ter Brugghen may have intended his painting as a more general allegory of musical harmony.

GERRIT DOU (1613–1675)

4　*A Woman playing a Clavichord*, about 1665

Oil on oak panel, 37.7 × 29.8 cm
Dulwich Picture Gallery, London (DPG 56)

The quietest of all keyboard instruments, and with
a fingering that was difficult to master, the clavichord
(see p. 74) was ideal for practice, solo playing, or to
accompany small ensembles. Dou's choice of this
particularly intimate instrument enhances the coy
invitation implied by the woman's outward gaze, the
curtain drawn up to 'reveal' the scene, and the bass viol
placed provocatively in the foreground. The distinctive
flame-shaped soundholes are occasionally seen on
surviving seventeenth-century viols. The bow tucked
under the viol's strings, and the open music book and
recorder on the table – in conjunction with the glass
of wine – are all designed to entice the viewer to come
forward and join the young woman in a private duet.
Dou's decision to place a viol (rather than another
instrument) in this leading position undoubtedly also
reflects the popular notion that the instrument's sensual
form was akin to that of a woman's body. The implied
invitation to caress the objects placed so temptingly in
the foreground of the painting, coupled with the woman's
own delicate fingering of the clavichord's keys, also
emphasise the sense of touch. In this way, Dou deliberately
draws our attention to his extraordinarily accomplished
rendering of tactile surfaces.

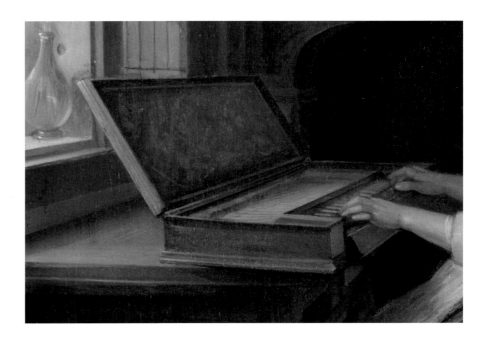

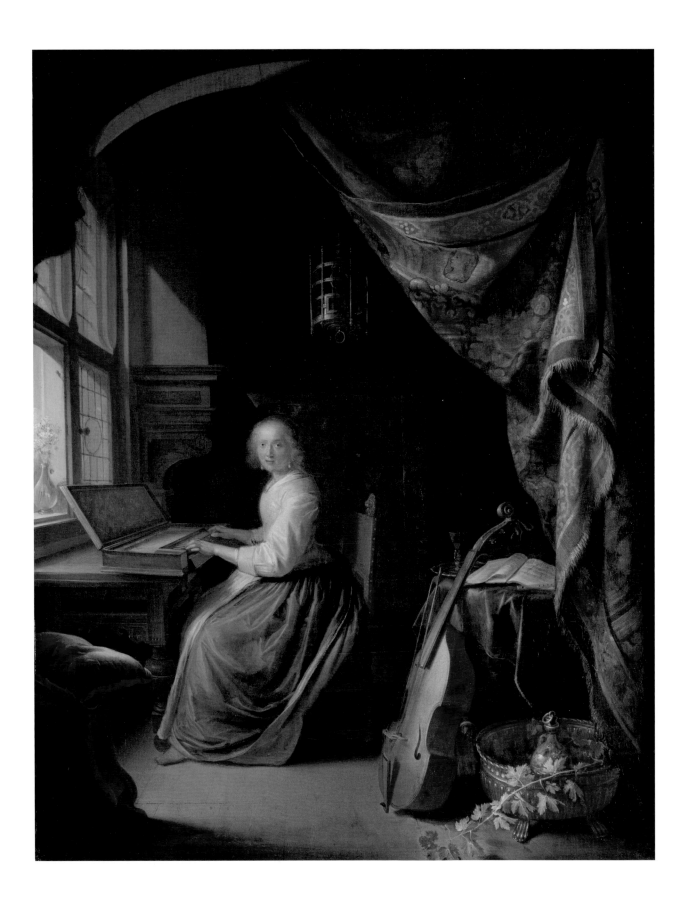

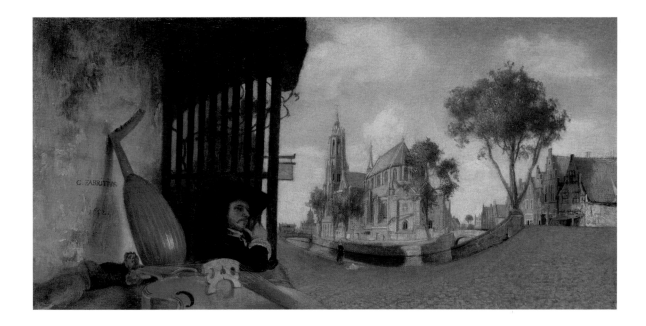

CAREL FABRITIUS (1622–1654)

5 *A View of Delft, with a Musical Instrument
 Seller's Stall*, 1652

Oil on canvas stuck onto walnut panel, 15.5 × 31.7 cm
The National Gallery, London (NG 3714)

This unusual painting may originally have been part
of a perspective box, a viewing device that would have
brought the wide city panorama into proper perspective
for the viewer. At the far left is a man seated beside a
table or counter, possibly a musical instrument seller's
stall; on the counter are a lute and a dramatically fore-
shortened viola da gamba. In the background is Delft's
Nieuwe Kerk, where the young stadholder of the Dutch
Republic, Willem II (1626–1650), had been buried
only a few years before. The pensive figure seems lost
in a melancholic reverie, perhaps contemplating the
transience of life, of which the stilled musical
instruments beside him are a potent reminder.

PIETER DE HOOCH (1629–1684)

6 *A Musical Party in a Courtyard*, 1677

Oil on canvas, 83.5 × 68.5 cm
The National Gallery, London (NG 3047)

Rather than the more commonplace violin, de Hooch's
musician appears to be playing a tenor viola, a large-
bodied instrument popular throughout Europe until
about 1700. Although her underhand bow-hold is accurate,
the player's standing pose may be an artistic conceit: tenor
violas were usually played resting on the knee. On the
other hand, resting a quiet stringed instrument on a
table whilst playing may have increased its volume and
audibility through sympathetic resonance.

 The meagre light that illuminates this secluded
terrace emphasises the intimacy of the scene; the boy
silhouetted in the doorway seems to guard against any
intruders as the solo musician provides private entertain-
ment. Violins and viols often had erotic connotations:
not only were they associated with dance music (and
therefore questionable morals), but their curvaceous
shape was likened to a woman's body. Although the
man gestures towards the musician with one hand, his
attention is completely focused on the young woman
seated beside him, who smilingly returns his gaze as she
stirs her drink. The nature of their relationship is not
clear – it may be that the woman is a prostitute – but
de Hooch has provided all the traditional components
of an evening's entertainment: wine, women and song.

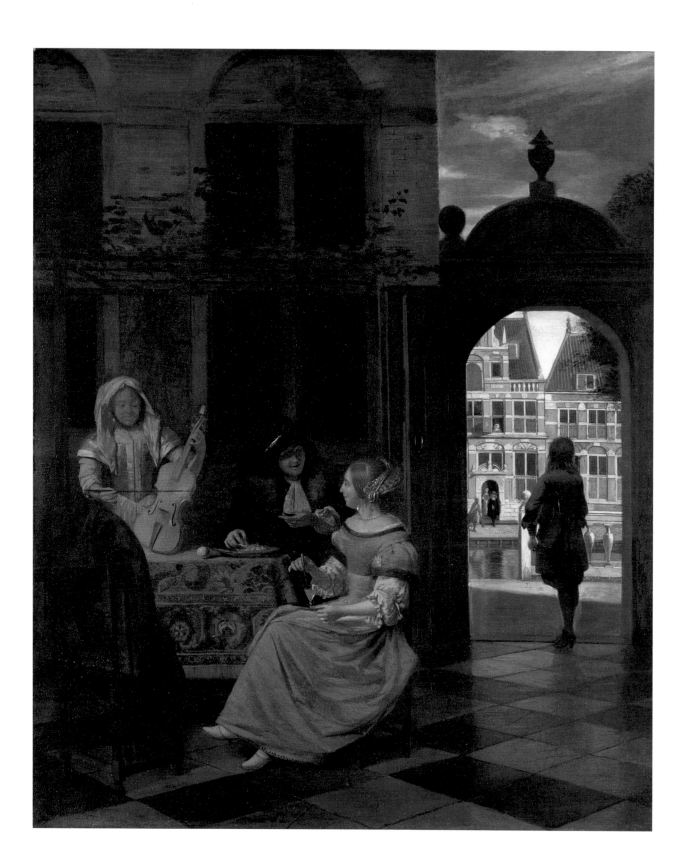

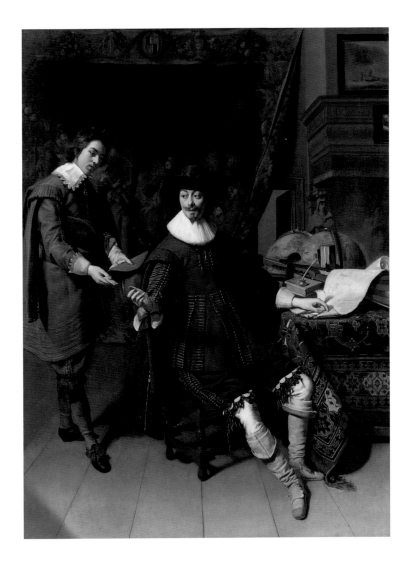

THOMAS DE KEYSER (1596/7–1667)

7 *Portrait of Constantijn Huygens
and his (?) Clerk*, 1627

Oil on oak, 92.4 × 69.3 cm
The National Gallery, London (NG 212)

Complementing an impressive career as secretary
to three successive Dutch stadholders, Constantijn
Huygens (1596–1687) was a prolific writer and poet,
a respected critic and artistic advisor – yet still found time
to feed his life-long passion for music. The diversity of
Huygens's interests is suggested by the array of objects
heaped on the table at his side, which includes books,
globes, an inkpot, architectural plans, compasses and
a timepiece. Music is represented by an archlute, an
adaptation of the lute with an extension to the neck

and a second pegbox (hidden behind Huygens's arm)
to carry the bass strings.

Huygens's hobbies of playing and composing music,
and collecting musical instruments, scores and books
on musical theory implied a high level of sophistication
and discernment. His musical interests both utilised and
strengthened the extensive network of foreign contacts
he had built up during his years of diplomatic service.
Music must also have provided a welcome respite from
the cares and stresses of his professional life. Shortly
before his death in 1687, at the age of ninety, Huygens
wrote to his friend and fellow amateur musician
Diego Duarte that though frustrated by the gout
that had weakened his fingers, he was still able to play
accompaniment on the theorbo, well enough that
'a drunken peasant would not be aware of the defect'
in his playing.

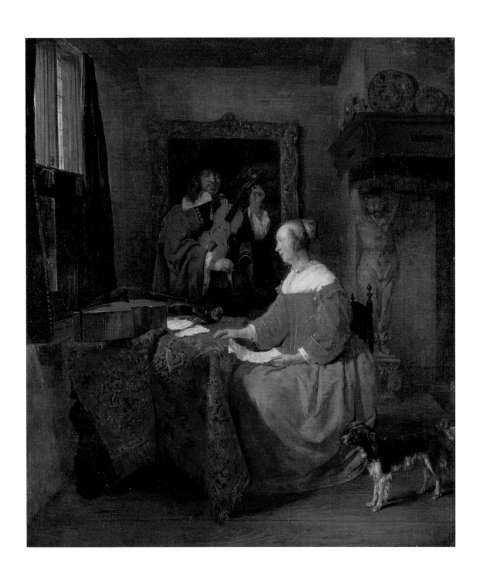

GABRIEL METSU (1629–1667)

8 *A Woman seated at a Table and a Man tuning a Violin*, about 1658

Oil on canvas, 43 × 37.5 cm
The National Gallery, London (NG 838)

The man props his violin against his chest as he tunes the instrument. In seventeenth-century imagery, tuning a musical instrument in preparation for a duet is often interpreted as a prelude to love. The woman holds one of several music sheets in her hand and on the table before her is a viola da gamba. Her lips are slightly parted, and it has been suggested that the man tunes his violin to her singing. This is a practical impossibility, however, as a sung pitch is not stable enough to tune to (see also cat. 15). Metsu's painting was at one time in the collection of the French harp- and piano-maker, Sébastien Erard (1752–1831).

9 *A Man and a Woman seated by a Virginal,*
about 1665

Oil on oak, 38.4 × 32.2 cm
The National Gallery, London (NG 839)

The clear, precise geometry of Metsu's composition underscores the peaceable harmony that surrounds the two figures. No music is being played; instead, a more direct (and perhaps more intimate) exchange takes place, as the woman holds out a music sheet and the man tips his glass in her direction. On the table beside him is a violin, presumably just laid aside. Quite a different sort of musical scene is depicted in the painting in the background, a variant of Metsu's own exuberant *Twelfth Night Feast*, an event usually associated with wild revelry and raucous sing-alongs. The mottos printed on the virginal lid, [I]N TE D[O]MINE SPERAVI NON CONF[UN]DAR I[N] AETERNV[M] ('In thee, O Lord, have I trusted; let me never be confounded'); and front flap, OMNIS [SPIRITUS LAUDE]T DOMINU[M] ('Let every soul praise the Lord'), are both taken from the biblical book of Psalms. Metsu depicted the same virginal in at least three other paintings.

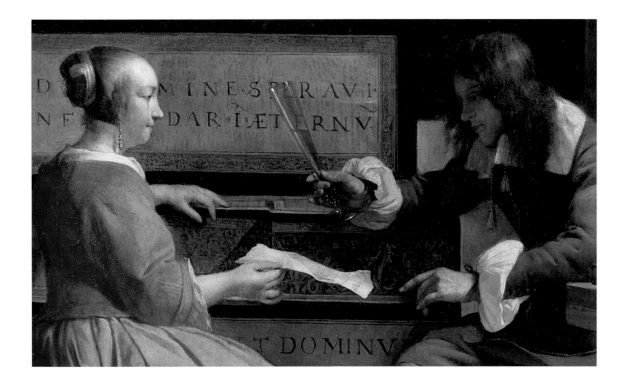

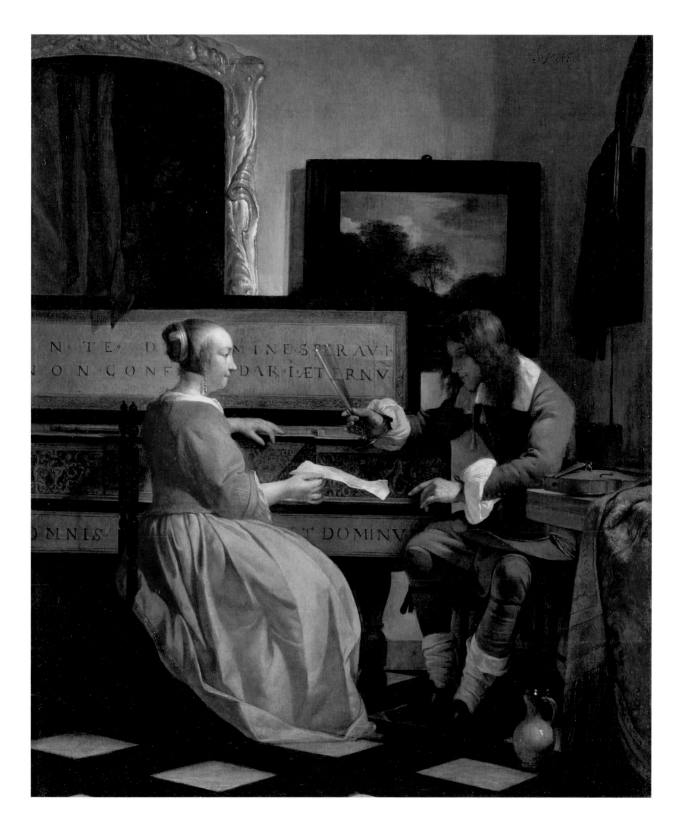

FRANS VAN MIERIS THE ELDER (1635–1681)

10 *Self Portrait of the Artist, with a Cittern*, 1674

Oil on canvas, 17.5 × 14 cm
The National Gallery, London (NG 1874)

It was not uncommon for Dutch painters to depict
themselves playing a musical instrument, usually a
stringed instrument such as a lute or cittern. This is often
interpreted as an attempt to elevate the perceived status
of painting, which many in the seventeenth century still
considered an artisanal craft devoid of intellectual merit.
As the theory, if not the practice, of music was based on
mathematics, it was more highly regarded, and considered
fundamental to the formation of a virtuous, knowledge-
able, and articulate citizen. By intimating that he had
mastered a musical instrument, van Mieris laid claim
to a certain level of education and social status. Only the
upper portion of the cittern is visible here, showing the
distinctive curved neck and a pegbox with ten pegs topped
by a decorative head. The ribbon knotted around the neck
was used to hang up the instrument. The seventeenth-
century Antwerp collector and amateur musician Diego
Duarte (see fig. 6) owned a small self portrait by Frans
van Mieris, 'dressed *à l'italienne* and playing a lute',
which may be identical to this painting.

JAN MIENSE MOLENAER (about 1610–1668)

11 *Two Boys and a Girl making Music*, 1629

Oil on canvas, 68.3 × 84.5 cm
The National Gallery, London (NG 5416)

This scene of children making a gleeful racket on violin,
rommelpot (see p. 76) and improvised drum is one of
the few paintings in the Gallery to show a more humble
musical scene. Although to us the violin might seem out
of place in this lowly context, for much of the seventeenth
century it was not highly regarded as a musical instrument.
It was primarily played by dance musicians, and by
itinerant performers eking out a living at taverns and
country fairs. The young girl has appropriated a morion
(a type of helmet common among European foot soldiers)
to use as a drum, and wears a soldier's metal gorget over
her shoulders. The ragged rommelpot player has a
chicken claw and a sprig of acorns stuck jauntily through
the brim of his hat. Both were part of the insignia of
the *Kloveniers* (Arquebusiers), one of the three branches
of the local civic militia. Like other artists before him,
Molenaer often used the antics of children to poke fun
at the grown-up world; here, he may have intended a
contrast between the playful innocence of children and
the vain militaristic preoccupations of adults.

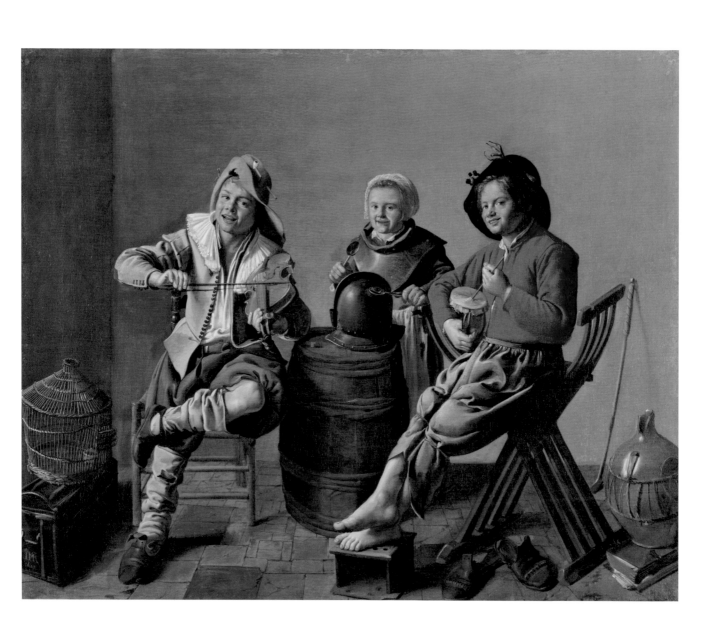

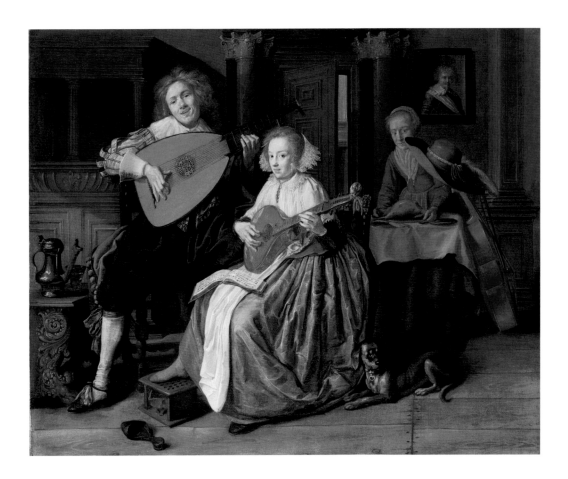

JAN MIENSE MOLENAER (about 1610–1668)

12 *A Young Man and a Woman making Music,*
probably 1630–2

Oil on canvas, 68 × 84 cm
The National Gallery, London (NG 1293)

From sophisticated family portraits (fig. 17) and musical companies to more raucous enjoyments (cat. 11) musical themes appear regularly in Molenaer's work. This amiable young man plays a two-headed 'French' lute, while the woman strums a five-course cittern with a plectrum held between her fingers. Just below the brightly painted head at the top of the cittern's pegbox is a knot of ribbons, probably used to hang up the instrument when not in use.

Leaning against the table to the right is a cello, with a hat slung over the pegbox. The prominence of this odd motif suggests that it has particular significance. One of the more popular traditional meanings given the hat was as a symbol of liberty; to a seventeenth-century Dutch audience, this would have recalled the nation's recent struggle for independence from Spain. On the rear wall is a portrait of the stadholder Frederik Hendrik (1584–1647) who, following the revolt, attempted to reconcile religious and political factions within the Dutch Republic and bring them into concord. Molenaer's painting has been interpreted as a multi-faceted allegory of harmony: both political harmony, and the amorous and domestic harmony that thrive in its wake.

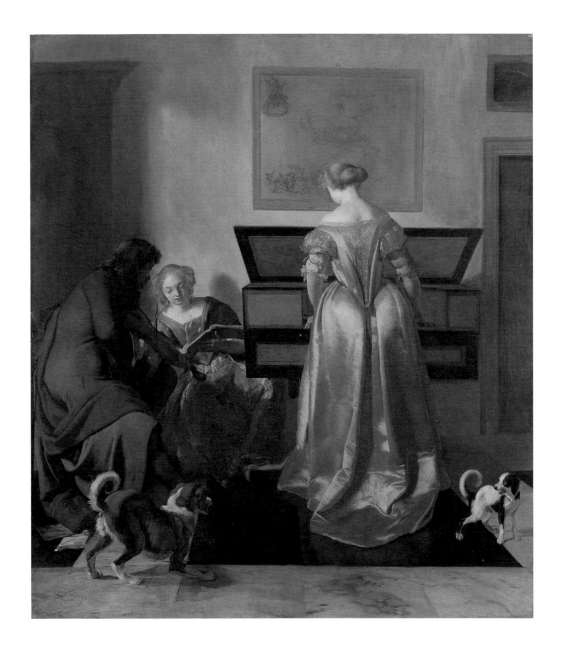

JACOB OCHTERVELT (1634–1682)

13 *A Woman playing a Virginal, Another singing and a Man playing a Violin,* probably 1675–80

Oil on canvas, 84.5 × 75 cm
The National Gallery, London (NG 3864)

Although nearly a third of his paintings feature musical themes, here Ochtervelt seems more keen to convey the elegant ambiance and coquettish interactions of this musical gathering than to portray specific, easily recognisable instruments. Standing at the keyboard with her back to us, the virginal player seems cut off from the more intimate exchange taking place between the violinist and the singer. Those figures incline towards each other as if swaying in response to the music. The behaviour of the dogs – facing off against each other across an expanse of polished floor – seems to comment on the equally ritualistic social dance performed by their human counterparts.

The National Gallery owns a second painting by Ochtervelt with a musical subject, *A Woman standing at a Harpsichord, a Man seated by her,* probably also painted about 1675–80 (NG 2143).

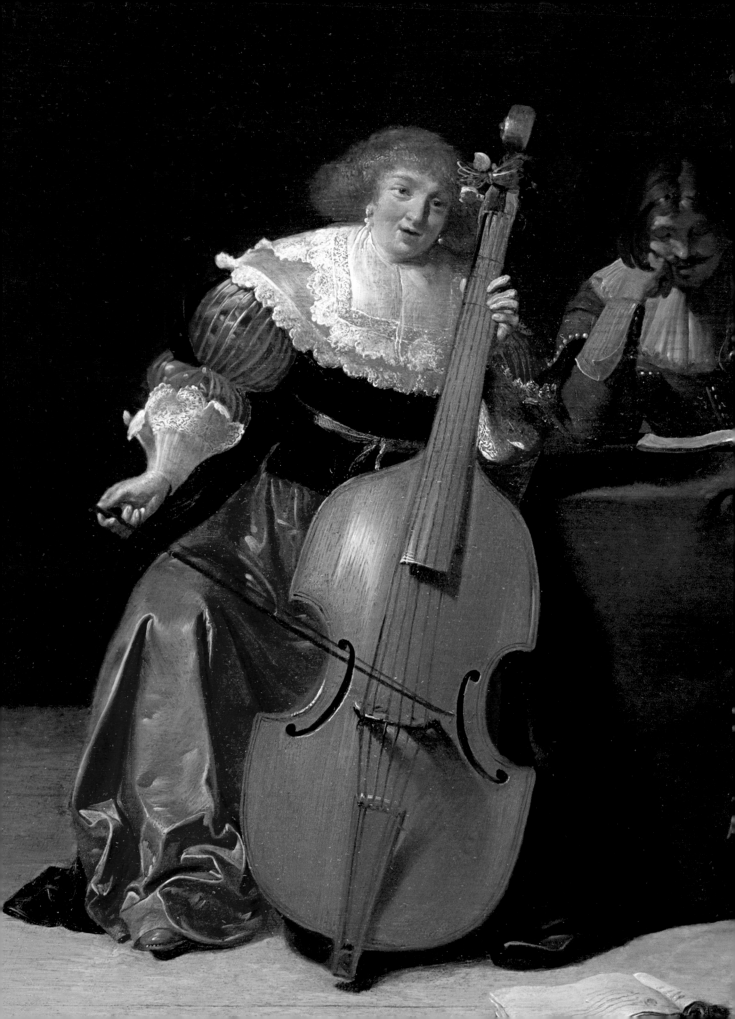

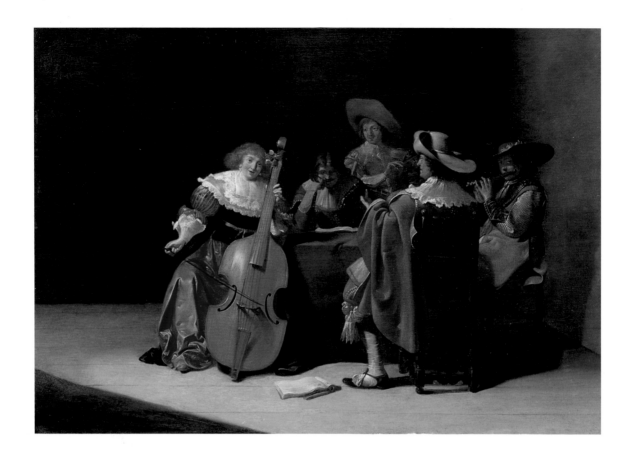

JAN OLIS (about 1610–1676)

14 *A Musical Party*, 1633

Oil on oak, 36.7 × 52.8 cm
The National Gallery, London (NG 3548)

Five musicians are gathered around a table in an other-
wise bare room. The ensemble consists of a ten-course
lute, a transverse flute, a violin, a viola da gamba, and
a man who appears to be singing: his mouth is open
and he studies an open (music) book, but his slumped
posture would hardly win the approval of a singing coach.
Although both men and women played the viola da
gamba in the seventeenth century, women are rarely
shown playing it in paintings. The usual manner of
holding the instrument between the knees could be
considered indecorous, and often had erotic overtones.

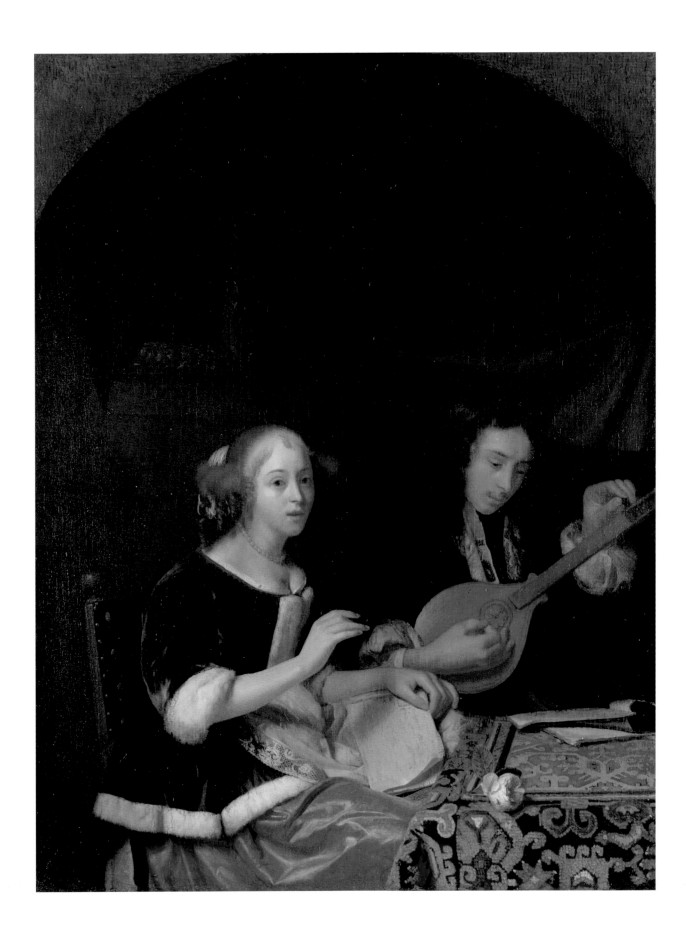

15 *A Woman singing and a Man with a Cittern,*
about 1665–70

Oil on oak, 26.6 × 20.4 cm
The National Gallery, London (NG 998)

The man tunes his cittern, holding a plectrum held
between his thumb and forefinger as he adjusts the
tuning peg. On the table before him is a music book.
His female companion holds a music book open on her
lap; her right hand is upraised and her mouth open as
if singing. The theme of Schalcken's painting recalls
an emblem from Jacob Cats's *Sinne- en Minnebeelden*
(*Images of Allegory and Love*, 1618) entitled 'Quid non
sentit amor' ('Who does not feel love?'; fig. 19), which
draws a parallel between the harmonic resonance of
stringed instruments and the idea of lovers' hearts
beating in tandem. Although it might look as if the man
is tuning to the sound of the woman's voice, this is surely
an artistic invention, as it is impossible to tune to a sung
pitch. The cut rose on the table may allude to a popular
conceit that likened music to a garden; alternatively,
Schalcken may have intended the fragile bloom to
suggest the transitory nature of musical performance
and also, perhaps, of the woman's youthful beauty.

JAN STEEN (1626–1679)

16 *A Young Woman playing a Harpsichord*
to a Young Man, probably 1659

Oil on oak, 42.3 × 33 cm
The National Gallery, London (NG 856)

The harpsichord bears two inscriptions: on the lid,
ACTA VIRUM PROBANT ('actions prove the man');
and, on the keywell lid dropped down at the front of the
instrument, SOLI DEO GLORIA ('solely for the glory
of God'). Steen wrote his own name on the name batten
immediately above the keys, where the instrument maker
typically would have signed his work. The decoration
is characteristic of keyboards produced by the Ruckers
workshop in Antwerp (see fig. 13).

Steen makes the harpsichord and its inscriptions
an active 'player' in the painting's narrative, linking the
protagonists in a courtship ritual that is, by design,
charmingly and amusingly awkward. The prim young
woman – her lowered gaze and upright posture expressing
exemplary decorum and emotional detachment – plays
'solely for the glory of God'; while the man – slouching
over the instrument and staring intently at the young
woman – is about to take more active steps. In the right
background a boy advances with an outsized theorbo;
presumably the man will soon attempt to breach the
woman's defences by proposing an intimate duet.

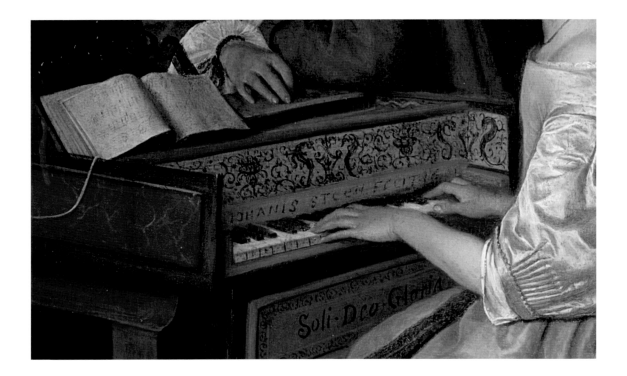

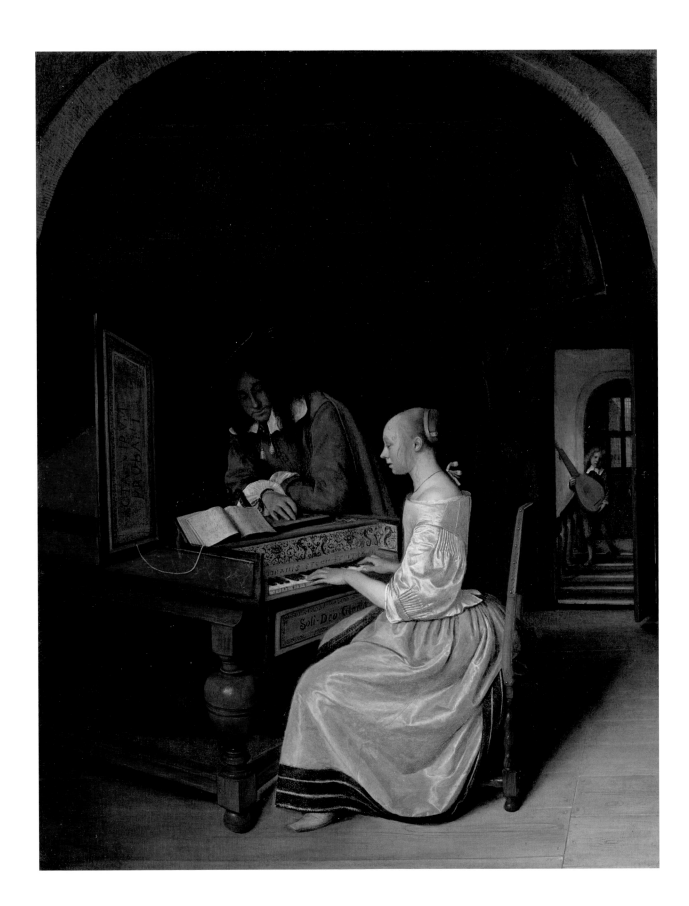

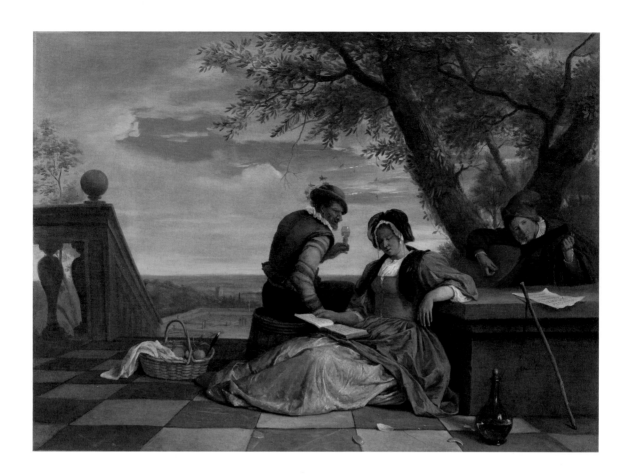

JAN STEEN (1626–1679)

17 *Two Men and a Young Woman making*
 Music on a Terrace, about 1670–5

Oil on canvas, 43.8 × 60.7 cm
The National Gallery, London (NG 1421)

Many of Jan Steen's genre paintings seem to come
directly from the comedy stage; he also painted scenes
from popular burlesque songs of the day. This painting
may well have such a musical or theatrical source,
although a specific one has not yet been identified.
It has the casual air of a troupe of roving performers
who have spontaneously paused in their travels for
a bit of refreshment. The garments worn by the man
at the centre represent a type of archaic (and therefore
vaguely ludicrous) costume usually associated with
old fools. Wineglass in hand, he focuses his attention
on the much younger woman seated beside him – yet
she seems quite oblivious to him. The lute player at
the right resembles certain stock figures in Commedia
dell'Arte performances. His squint suggests that he is
short-sighted, and therefore listens all the more closely
to the sounds he coaxes from his instrument as he tunes
it; or perhaps he strains to read the music sheet on the
ledge before him. He seems so intently focused on this
task that he may have lost sight of fact that his tuning
is delaying any actual performance.

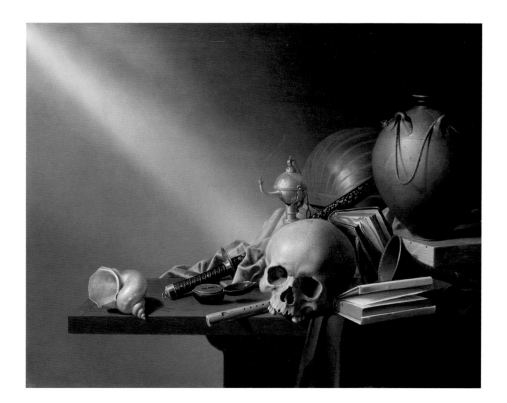

HARMEN STEENWYCK (1612–1656)

18 *Still Life: An Allegory of the Vanities of Human Life,* about 1640

Oil on oak, 39.2 × 50.7 cm
The National Gallery, London (NG 1256)

In Steenwyck's elegant *vanitas* allegory, musical instruments, a ubiquitous symbol of earthly pleasure, are grouped with costly objects that refer to other temporal concerns: books symbolise knowledge; the Japanese sword, power and wealth; the seashell (an expensive collectors' item), wealth and acquisitiveness; and the timepiece, skull, and extinguished lamp, the passage of time. Tucked beneath the skull, the recorder is especially clearly depicted. A maker's mark stamped just below the window of the instrument indicates it was made by the Schnitzer family, German wind instrument manufacturers active in Munich and Nuremberg. The bell of a shawm (see p. 76) is visible on the lower right; further back in the composition, a gleam of light accentuates the swelling form of a lute.

JAN JANSZ. TRECK (1605/6–1652)

19 *Vanitas Still Life,* 1648

Oil on oak, 90.5 × 78.4 cm
The National Gallery, London (NG 6533)

Treck's colourful composition brings together objects representing a broad range of worldly pursuits: an iron helmet, a chest for storing precious objects, books and documents, a drawing, an earthenware wine jug, a slender clay pipe, and a length of costly silk fabric. A skull and an hourglass are unmistakable allusions to the transitory nature of human existence. Musical references include a stringed instrument, probably a violin (only the neck can be seen); a bow tucked beneath a music book; and a recorder wedged behind the hourglass. The latter juxtaposition embodies the concept of music requiring time to be performed: death interrupts the passage of time and life, and thus also the playing of music. Similarly, the shallow shell and reed used for blowing bubbles resting upon the open music book is a reminder of the inherently ephemeral aspect of musical performance.

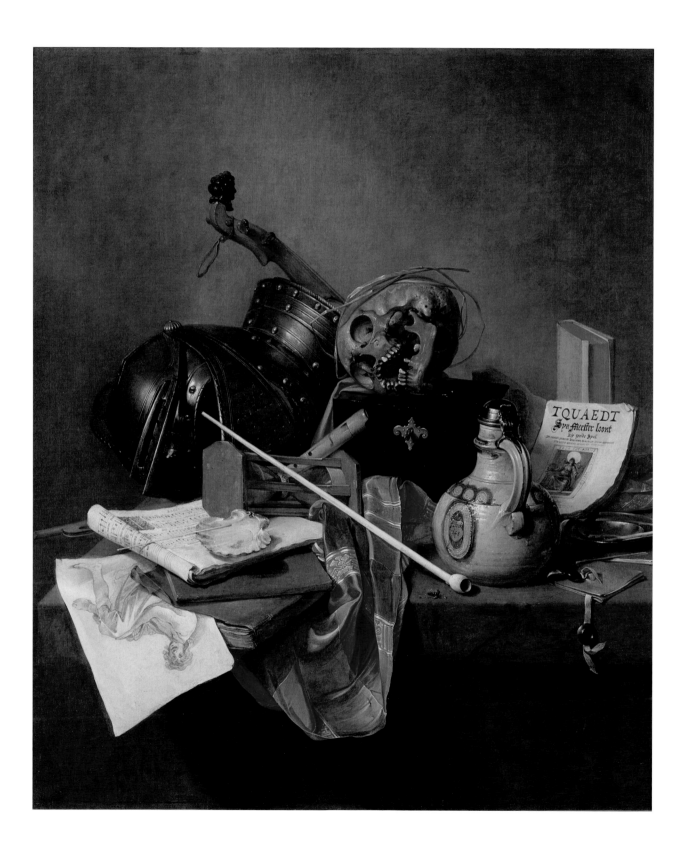

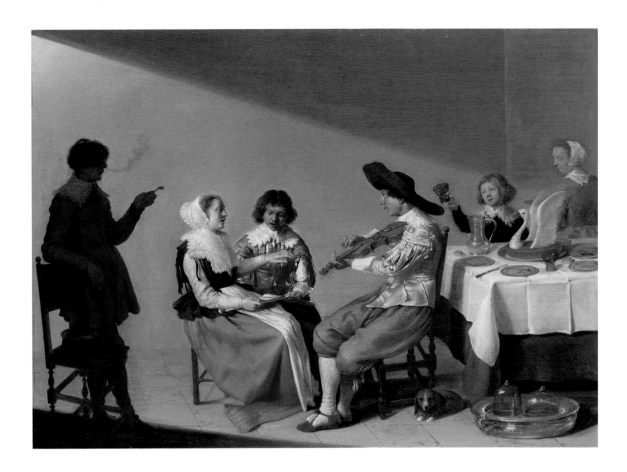

JACOB VAN VELSEN (about 1597–1656)

20 *A Musical Party*, 1631

Oil on oak, 40 × 55.8 cm
The National Gallery, London (NG 2575)

In this convivial gathering of well-to-do young adults, a
stylish man plays the violin as another man and a woman
sing from a shared music book. She marks time with her
upraised hand, while her companion uses his finger to
follow the printed score. Although it seems quite natural-
istic, van Velsen's composition may harbour echoes of
the allegorical representations of music popular in the
sixteenth century. The gesture of marking the beat, the
tactus, was often invoked as a symbol of moderation.

Seated at the centre of the composition, the trio of
musicians are caught between two tempting intoxicants:
smoking, flagrantly enjoyed by the shadowy figure on
the left; and drinking, represented by the wine bottles
in the cooler and the glass held up by the young boy.
Perhaps the musicians avoid the moral pitfalls of excessive
consumption by focusing on their music; or perhaps they
enjoy (with due moderation) the seductive pleasures of
a third intoxicant, music itself.

Van Velsen's painting might also embody an allegory
of the senses, with the smoker on the left representing
Smell; the food and wine, Taste; the music, Hearing; the
marking of the beat, Touch; and the long look exchanged
between the violinist and the female singer, Sight.

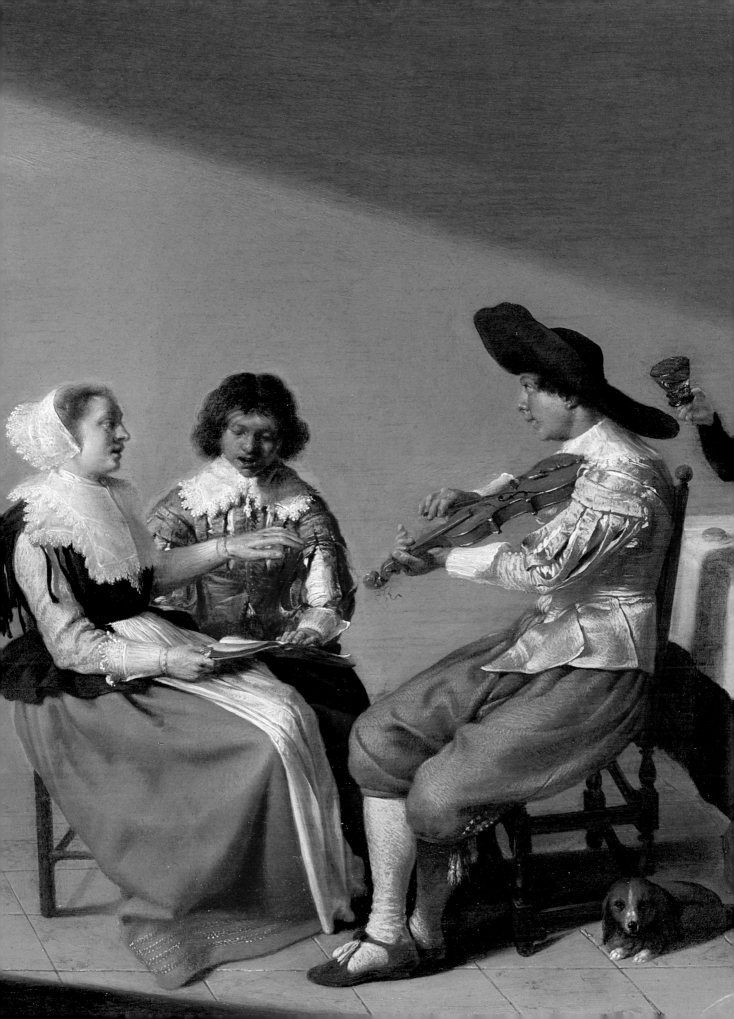

JOHANNES VERMEER (1632–1675)

21 *The Music Lesson,* about 1662–3

Oil on canvas, 73.3 × 64.5 cm
Royal Collection Trust / HM The Queen
(RCIN 405346)

At the far end of this expansive room is a woman
playing a muselar virginal (see p. 75), evidently for the
enjoyment of the man standing to her side. His lips are
slightly parted, as if he is singing. The suggestion of
any more intimate contact between the two figures is
left deliberately vague, although the image reflected in
the mirror on the wall above the woman's head hints
at a coy exchange of glances. Nearer to us is a viola da
gamba with a bow tucked under the bridge, presumably
awaiting a player to join in.

The decoration of the virginal in Vermeer's painting
suggests that it was inspired by an instrument produced
by the Ruckers workshop in Antwerp (see fig. 13). The
decorative paper on the front of the instrument, printed
with an intricate design of arabesques, and the Latin
motto on the lid, are particularly characteristic. The motto
itself, 'MUSICA LETITIAE CO[ME]S MEDICINA
DOLOR[IS]' ('Music is the companion of joy, the
medicine of sorrow'), refers to music's alleged curative
properties. It also alludes to the fact that love can be a
source of both joy and sorrow – particularly those tenta-
tive, strictly governed, but nonetheless intense emotions
that Vermeer evokes so eloquently in this painting.

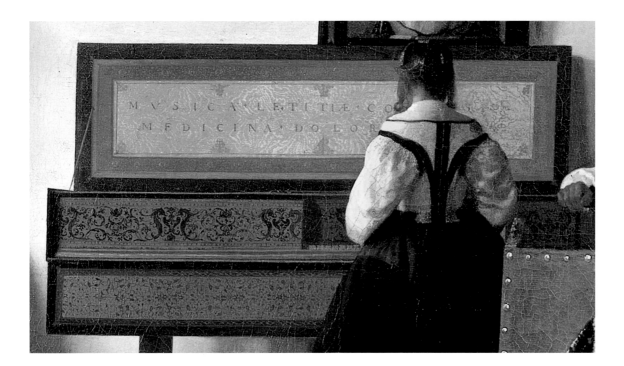

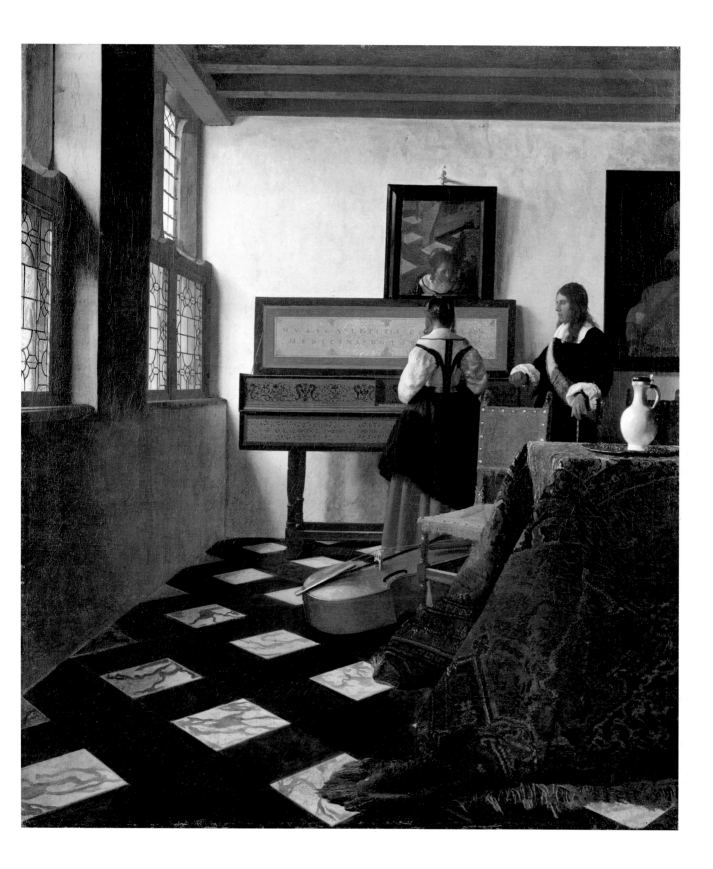

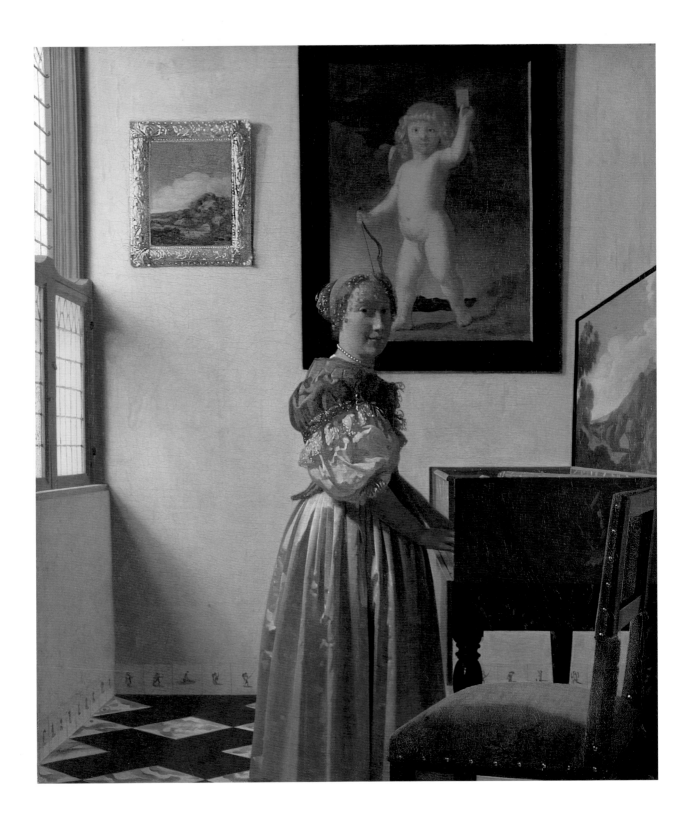

JOHANNES VERMEER (1632–1675)

22 *A Young Woman standing at a Virginal*, about 1670–2

Oil on canvas, 51.7 × 45.2 cm
The National Gallery, London (NG 1383)

Both this painting and the *Young Woman seated at a Virginal* (cat. 23) feature a muselar, a type of virginal that has the keyboard positioned to the right of centre and produces a characteristically warm sound. The instruments' painted imitation marble exteriors are typical of keyboards made by the Ruckers workshop in Antwerp (see fig. 13), but it is impossible to identify Vermeer's instruments as the work of a particular maker. The painted landscape decorating the lid – rather than patterned paper with a printed motto, as seen on keyboards in paintings by Metsu, Ochtervelt, Steen and even Vermeer himself (cats 9, 13, 16, 21) – suggests that this is a particularly deluxe instrument. Instrument builders usually left the lid, soundboard, and the area above the keys plain so that clients could decide for themselves how to ornament them: decorations by a noted artist could easily double the cost of an instrument. In this instance, Vermeer 'decorated' his virginal with a landscape painting in the style of a Delft colleague. Seventeenth-century keyboard instruments were typically constructed without attached legs, and were either placed on a tabletop (cat. 4) or positioned on a dedicated stand, which could vary in height according to the owner's wish: thus we see keyboard players both sitting (cats 9, 16, 23, 25) and standing (cats 13, 21).

Either this painting or the *Young Woman seated at a Virginal* (cat. 23) may have been owned by the Antwerp collector Diego Duarte; he paid 150 guilders for a painting by Vermeer of a woman playing the '*clavesingel*' (a generic term used to describe all plucked keyboard instruments), perhaps purchasing it directly from the artist himself.

JOHANNES VERMEER (1632–1675)

23 *A Young Woman seated at a Virginal,* about 1670–2

Oil on canvas, 51.5 × 45.5 cm
The National Gallery, London (NG 2568)

We do not know whether Vermeer conceived *Young Woman seated at a Virginal* specifically as a companion piece to *Young Woman standing at a Virginal* (cat. 22), but the two paintings were certainly painted at about the same time, and present contrasting explorations of the theme of a solo female musician. Rather than standing upright in a room illuminated by clear daylight, this musician is seated before her virginal, and the room's dusky shadows suggest that it is night-time, with unseen lamps or candles providing minimal light. A viola da gamba in the foreground beckons the viewer into the scene, perhaps to join the woman in a duet. The gamba player's role is a significant one: most music of the Baroque era featured the *basso continuo*, in which the bass line (often supplied by the viola da gamba) was key to the harmonic structure. On the wall in the background, Vermeer has included another musical subject: a painting by Dirck Baburen of a prostitute playing a lute, with a procuress demanding payment from the prospective customer. By including this painting-within-a-painting, Vermeer may have intended a contrast between different aspects of music as a metaphor for harmony: the pure, honourable love between a man and a woman versus more mercenary forms of sexual relations. Baburen's original painting is today in the Museum of Fine Arts, Boston.

Curiously, although a third of Vermeer's paintings feature music in some form, no musical instruments are mentioned in the inventory of personal property drawn up shortly after the artist's death in 1675. He knew the painting by Baburen well, however, as it was owned by his mother-in-law.

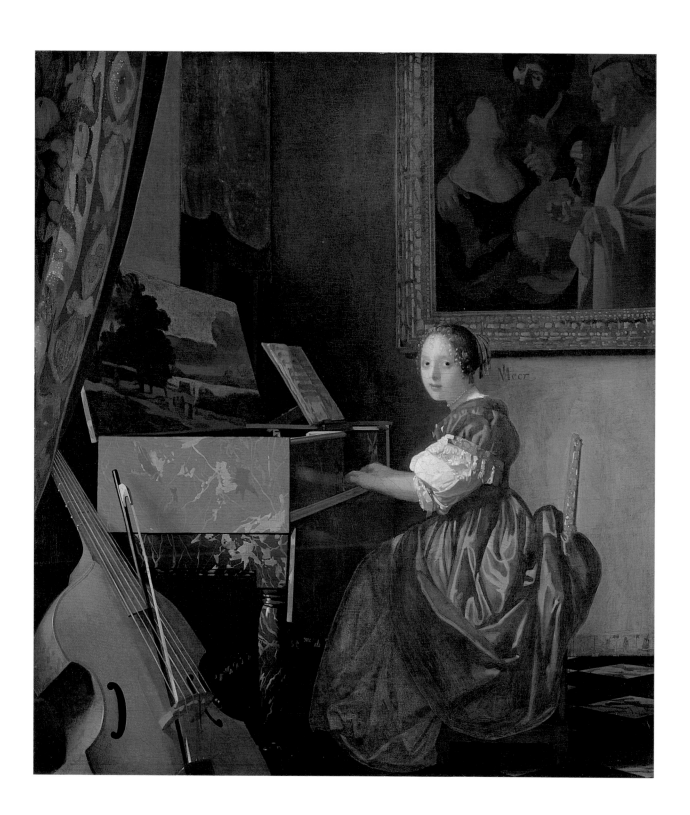

24 *The Guitar Player*, about 1672

Oil on canvas, 53 × 46.3 cm
On loan from English Heritage,
The Iveagh Bequest (Kenwood) (88028841)

Rather than positioning his guitar player at the centre of the composition, Vermeer placed the figure far to the left, cloaking the right half of the painting in half-light and shadow. The pleasant imbalance imparts a sense of movement and impending change to this deceptively simple image. With tipped head and a pert smile, the woman fixes her gaze on something just outside the image: some magnetic presence seems to pull her from our view, suggesting that she now plays not for us, but for this unseen visitor.

Focusing the composition on just a single figure places greater importance on the instrument being played. In the seventeenth century, the guitar was used as both a solo and continuo (harmonic) instrument; its sound was rather delicate, not as loud as the modern flamenco guitar. The gut strings were played with the fingers, using a combination of melodic fingering and *rasgueado*, typical Spanish rapid strumming of chords. The five-course guitar depicted in Vermeer's painting was standard for most solo repertoire. Although the guitar had been popular in France and Spain for some time, it had only recently been introduced in the Netherlands.

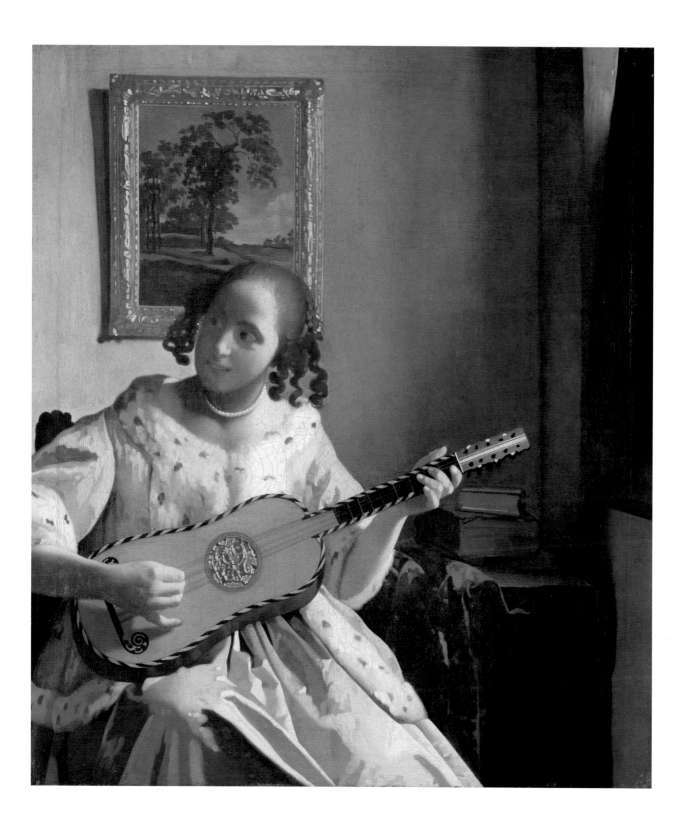

JOHANNES VERMEER (1632–1675)

25 *Young Woman seated at a Virginal*, about 1670–2

Oil on canvas, 25.5 × 20 cm
Private collection, New York

Young Woman seated at a Virginal demonstrates the
extreme simplification of form with which Vermeer
experimented in his late works. To an even greater
degree than in *The Guitar Player* (cat. 24), he narrows
his focus to the figure of a solo musician, here seated
before a muselar virginal. Her hands rest delicately on
the keyboard; her plump forearms are dimly reflected
in the gleaming surface of the instrument's painted case.
Yet for all its apparent simplicity, *Young Woman seated
at a Virginal* betrays Vermeer's sophisticated command
of light effects: the muted glimmer along the edge of
the music desk; the sparkling highlights of pearls in the
woman's hair and around her neck; and above all, the
luminous, roughly-textured background wall. By making
this wall the principal plane of focus and slightly blurring
the objects closest to us, Vermeer increases the magnetic
draw of the musician's direct gaze, thereby enhancing
the intimacy of her performance.

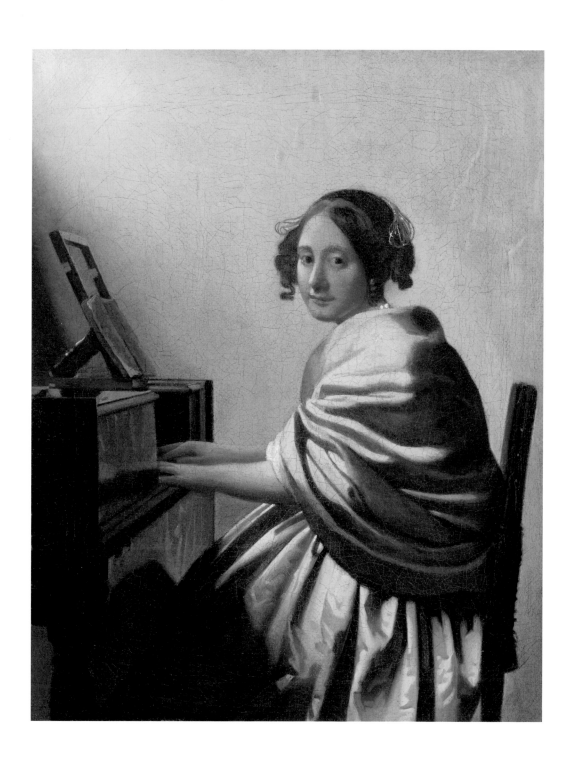

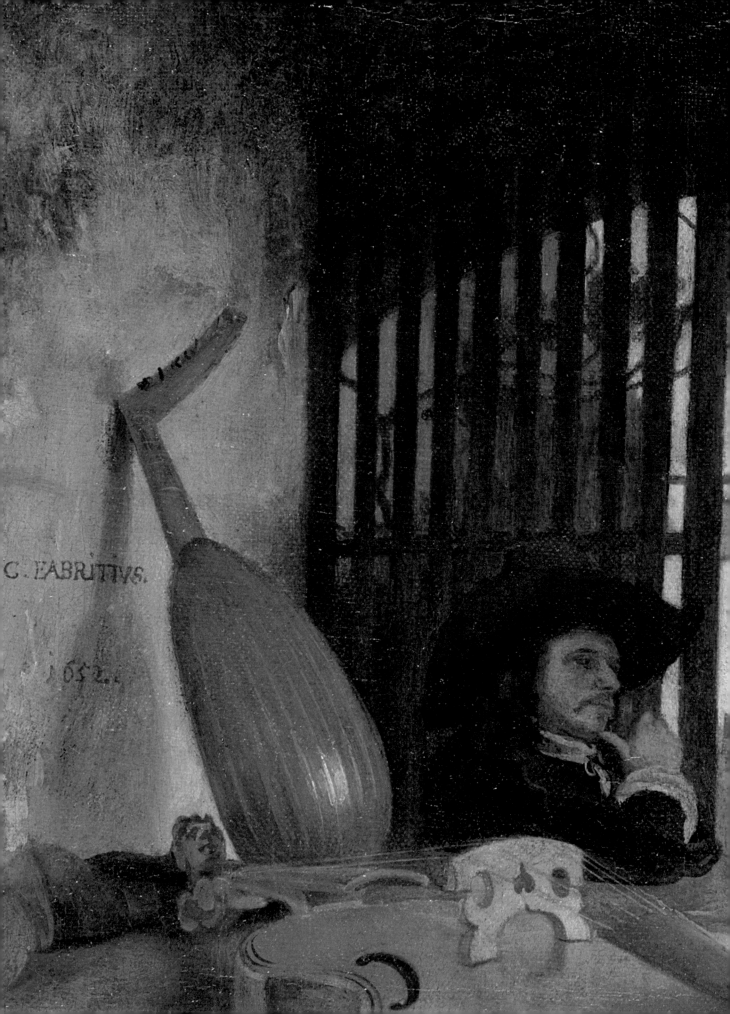

Glossary

Stringed Instruments

Stringed instruments are categorised according to whether they are plucked – either with the fingers or plectrum – or bowed. Most plucked instruments featured courses, which could either be a single string, or two adjacent strings tuned to the same pitch and played in one stroke to increase the volume of the instrument. Bowed instruments are played by drawing a wooden bow, tautly strung with horsehair, across the strings to produce a more sustained and resonant tone.

CITTERN

A popular instrument, easier to hold and less delicate than the lute, with a shallow, pear-shaped body, flat back, and four or six courses of strings. Played with a plectrum rather than strummed with the fingers, the cittern's wire strings produced a more piercing tone than gut-strung instruments, which enabled it to cut through the sound of bowed string and wind instruments in ensemble playing. It played harmony and provided rhythmic, chordal accompaniment to the melodic line.

See cats 10, 12, 15; and see figs 12, 17, 20

GUITAR

From its origins in Spain, the guitar's popularity spread quickly through Europe during the sixteenth century as a cheaper, easier to play alternative to the lute. Like the modern guitar, it had a flat front and back and a deep soundbox, but was more slimly proportioned; the pegbox was often set at a slight angle to the neck. Played by both plucking and strumming (*rasgueado*).

See cat. 24 and figs 6, 11

HURDY-GURDY

Popular lute-shaped instrument with strong rustic and folk associations. Strings were activated by a rotating wheel, turned by a crank positioned at the end of the instrument opposite the tuning pegs. The hurdy-gurdy had both drones, generating a sustained pitch, and melody strings; the pitch of the latter was modified by depressing keys to stop the strings at melodic intervals.

See fig. 22

LUTE

The body of the lute is almond- or gourd-shaped, with a flat soundboard and convex ribbed back; the pegbox is constructed at an angle to the neck. Frets, of gut strings tied around the neck, are moveable to allow for refinements in tuning. Sixteenth-century lutes typically had six courses, but in the seventeenth century this was increased to about ten, expanding the lower register of the instrument. Gut strings produced a soft, warm sound, making the lute a favoured instrument for accompanying the solo voice. Two-headed 'French' lutes, with additional bass strings and a second pegbox (but lacking the extended neck of the theorbo, see below) were introduced into the Netherlands in the seventeenth century.

See cats 1, 2, 3, 5, 12 (cats 1 and 12 show a two-headed lute), 14, 17, 18; and figs 4, 7, 8, 14, 17, 19, 20, 21

FIG. 22

Hurdy-gurdy (lower left, shaded), illustrated in Michael Praetorius (1571–1621), *Syntagma Musicum De Organographia*, 1619 (vol. 2, pl. XXII)

THEORBO (also theorbo-lute)

A type of lute fitted with an extended neck supporting unfretted bass strings and a second pegbox to accommodate them. Different permutations of the theorbo (including the chitarrone and the archlute) situate the second pegbox either above or slightly to the side of the first pegbox, and either in line with or at an angle to the neck. These instruments played a crucial role in accompanying both large and small ensembles.

See cats 7, 16; and fig. 16

VIOL (viola da gamba, 'English viol')

A family of bowed instruments, often supplied in several sizes together for playing consort music (music composed for instruments of the same family). The most common was the bass viol, used for both solo and ensemble playing. Although superficially similar to the cello, the bass viol differs in having C-shaped soundholes, sloping shoulders, a flat (rather than convex) back, six strings (although there were also viols with four, five or seven strings), and, as on the lute, gut frets tied around the neck. Played with the bow held underhand.

See cats 4, 5, 8, 21, 23; and figs 4, 6, 10

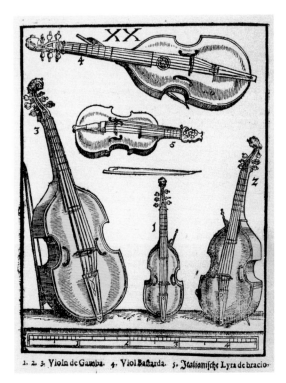

FIG. 23

Three viols, (lower half, shaded), illustrated in Michael Praetorius (1571–1621), *Syntagma Musicum De Organographia*, 1619 (vol. 2, pl. XX)

VIOLIN

Until the twentieth century, the strings of the violin were made of gut and had a lower tension, resulting in a quieter sound. The neck of the instrument was shorter, unfretted, and fixed at a shallower angle to the body than on the modern violin. There was no chin rest, as the violin was played resting against the chest, upper arm, shoulder or collarbone. The early violin bow was more convex, with a long tapering point. In the sixteenth century the violin was predominantly played by itinerant musicians in taverns and dance halls, but during the seventeenth century became more acceptable among elite audiences.

See cats 6 (tenor viola), 8, 9, 11, 13, 14, 19; figs 3, 4, 5, 9, 15

Keyboards

In the seventeenth century, the Dutch term *clavicimbel* (also *clavecijn*, *clavesingel*, or *clavesimbael*) was used to describe any keyboard instrument with a plucked action, including virginals and harpsichords. Antwerp was the most important centre for keyboard production in northern Europe through the late sixteenth and seventeenth centuries.

CLAVICHORD

A small keyboard instrument with a characteristically low volume. Sound is produced by a metal blade (tangent) striking the instrument's metal strings; with appropriately positioned tangents, a single string could be used to sound more than one pitch. The clavichord action afforded the player control not only over the dynamic level of the sound, but also – uniquely among keyboard instruments – allowed expressive effects such as vibrato to be produced.

See cat. 4 and fig. 24

HARPSICHORD

Similar in shape to a grand piano, the harpsichord was the largest stringed keyboard instrument in use from the sixteenth to the eighteenth century, and was popular as both a solo and ensemble instrument. Strings are plucked by a mechanism that forces a stiff quill past the metal string, making it sound. Some harpsichords had a double manual (two keyboards), either for transposing the music into another key, or to vary tone quality and volume.

See cat. 16 and fig. 24

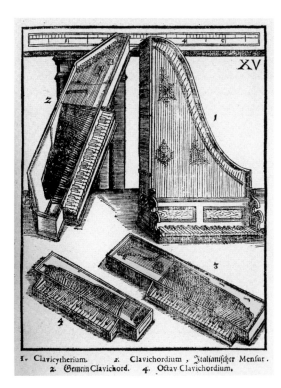

I. Clavicytherium. 2. Clavichordium, Italianischer Mensur.
 2. Gemein Clavichord. 4. Octav Clavichordium.

FIG. 24
Clavichord (lower half, shaded), illustrated in
Michael Praetorius (1571–1621), *Syntagma Musicum
De Organographia*, 1619 (vol. 2, pl. xv)

ORGAN

Keyboard instrument where sound is produced by forcing air
through pipes of different sizes. In addition to large organs
installed in churches, the small positive organ was popular for
domestic use. It often required two people to play, one to work
the bellows and the other to play the keyboard.
See fig. 6

VIRGINAL (also virginals)

Smaller than the harpsichord, Flemish virginals usually
had a rectangular case. The action is identical to that of the
harpsichord, but the strings run roughly at right angles to
the keys. In a muselar virginal, the strings are plucked near
the middle of their length, producing a rich, round tone; this
necessitated positioning the keyboard to the right of centre.
Spinet virginals situated the keyboard to the left of centre,
and plucked the strings closer to the bridge (a wooden bar
that positions the strings and helps transmit their vibration
to the soundboard), producing a more piercing sound. Most
seventeenth-century virginals had a compass, or range, of
around four octaves.
See cats 9, 13, 21, 22, 23, 25; and see figs 13 and 25

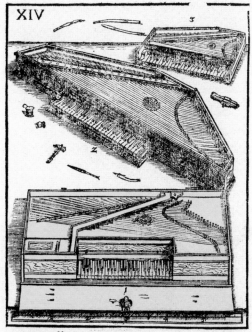

I. 2. Spinetten: Virginal (ingemein Instrument genant) so recht Chor-Thon.
 3. OctavInstrumentlin.

FIG. 25
Virginal (lower half, shaded), illustrated in Michael Praetorius
(1571–1621), *Syntagma Musicum De Organographia*, 1619 (vol. 2, pl. xiv)

Wind Instruments

BAGPIPE

Popular folk instrument constructed of a double or single reed pipe with fingerholes to create the melody, and an airtight reservoir, or bag, which the player inflated through a blowpipe. When compressed under the arm, the bag expels air through the melody pipe and drone pipes, causing the instrument to sound.

See figs 3, 7 and 26

FLUTE (transverse flute)

The sixteenth-century flute was a simple instrument made of wood, constructed in one piece with a blowing hole and six fingerholes. During the seventeenth century it became more sophisticated, constructed in three sections and with a key to close the hole for the lowest note. The fife, a smaller, simpler cousin to the flute, was mainly used in a military context.

See cats 3, 14; and see fig. 21

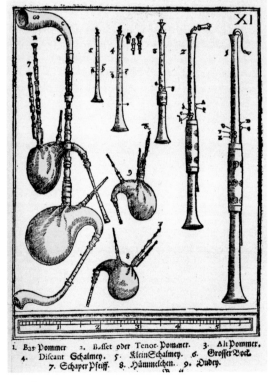

FIG. 26

Bagpipes (lower left, shaded), illustrated in Michael Praetorius (1571–1621), *Syntagma Musicum De Organographia*, 1619 (vol. 2, pl. XI)

RECORDER

Recorders existed in many sizes, from the great bass to the pocket-sized sopranino; all had seven fingerholes on the front and a thumbhole on the back. For much of the seventeenth century smaller recorders were turned from a single piece of wood, but during the final decades of the century they came to be constructed in three sections.

See cats 4, 18, 19

SHAWM

Double reed woodwind instrument with a flared bell. Like other woodwinds, shawms were made in several different sizes. They produced a loud, piercing sound and were typically used outdoors.

See cat. 18 and fig. 21

Brass Instruments

TRUMPET

Used mainly at court, in military contexts, and by city musicians, seventeenth-century trumpets were loud instruments without valves or keys. Individual notes of the scale were formed by a combination of specially shaped mouthpieces and lip technique.

FIG. 27

Trumpet, illustrated in Marin Mersenne (1588–1648), *Harmonie universelle: Contenant la theorie et la pratique de la musique*, 1636 (book 2, p. 248)

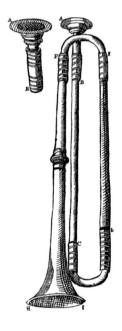

Percussion

ROMMELPOT

A type of friction drum mostly used by children and beggars. A wet pig's bladder was stretched over the opening of an earthenware pot or jug, and a stick inserted through the middle. Sound was produced by rubbing or moving the stick.

See cat. 11 and fig. 7

Glossary

List of Exhibited Works

All measurements give height before width.

Paintings

GERARD TER BORCH (1617–1681)

1 *A Woman playing a Lute to Two Men*,
 about 1667–8
 Oil on canvas, 67.6 × 57.8 cm
 Bought, 1871
 The National Gallery, London (NG 864)

HENDRICK TER BRUGGHEN (1588–1629)

2 *A Man playing a Lute*, 1624
 Oil on canvas, 100.5 × 78.7 cm
 Bought, 1963
 The National Gallery, London (NG 6347)

3 *The Concert*, about 1626
 Oil on canvas, 99.1 × 116.8 cm
 Bought with contributions from the
 National Heritage Memorial Fund,
 The Art Fund and The Pilgrim Trust, 1983
 The National Gallery, London (NG 6483)

GERRIT DOU (1613–1675)

4 *A Woman playing a Clavichord*, about 1665
 Oil on oak panel, 37.7 × 29.9 cm
 Dulwich Picture Gallery, London (DPG 56)

CAREL FABRITIUS (1622–1654)

5 *A View of Delft, with a Musical Instrument
 Seller's Stall*, 1652
 Oil on canvas stuck onto walnut panel,
 15.5 × 31.7 cm
 Presented by The Art Fund, 1922
 The National Gallery, London (NG 3714)

PIETER DE HOOCH (1629–1684)

6 *A Musical Party in a Courtyard*, 1677
 Oil on canvas, 83.5 × 68.5 cm
 Bought, 1916
 The National Gallery, London (NG 3047)

THOMAS DE KEYSER (1596/7–1667)

7 *Portrait of Constantijn Huygens and
 his (?) Clerk*, 1627
 Oil on oak, 92.4 × 69.3 cm
 Bequeathed by Richard Simmons, 1847
 The National Gallery, London (NG 212)

GABRIEL METSU (1629–1667)

8 *A Woman seated at a Table and a Man
 tuning a Violin*, about 1658
 Oil on canvas, 43 × 37.5 cm
 Bought, 1871
 The National Gallery, London (NG 838)

9 *A Man and a Woman seated by a Virginal*,
 about 1665
 Oil on oak, 38.4 × 32.2 cm
 Bought, 1871
 The National Gallery, London (NG 839)

FRANS VAN MIERIS THE ELDER
(1635–1681)

10 *Self Portrait of the Artist, with a Cittern*, 1674
 Oil on canvas, 17.5 × 14 cm
 May Bequest, 1854
 The National Gallery, London (NG 1874)

JAN MIENSE MOLENAER
(about 1610–1668)

11 *Two Boys and a Girl making Music*, 1629
 Oil on canvas, 68.3 × 84.5 cm
 The National Gallery, London (NG 5416)
 Not exhibited

12 *A Young Man and a Woman making Music*,
 probably 1630–2
 Oil on canvas, 68 × 84 cm
 Bought (Clarke Fund), 1889
 The National Gallery, London (NG 1293)

JACOB OCHTERVELT (1634–1682)

13 *A Woman playing a Virginal, Another singing
 and a Man playing a Violin*, probably 1675–80
 Oil on canvas, 84.5 × 75 cm
 Bought, 1924
 The National Gallery, London (NG 3864)

JAN OLIS (about 1610–1676)

14 *A Musical Party*, 1633
 Oil on oak, 36.7 × 52.8 cm
 Presented by Alfred A. de Pass, 1920
 The National Gallery, London (NG 3548)

GODFRIED SCHALCKEN (1643–1706)

15 *A Woman singing and a Man with a Cittern*,
 about 1665–70
 Oil on oak, 26.6 × 20.4 cm
 Wynn Ellis Bequest, 1876
 The National Gallery, London (NG 998)

JAN STEEN (1626–1679)

16 *A Young Woman playing a Harpsichord
 to a Young Man*, probably 1659
 Oil on oak, 42.3 × 33 cm
 Bought, 1871
 The National Gallery, London (NG 856)

17 *Two Men and a Young Woman making
 Music on a Terrace*, about 1670–5
 Oil on canvas, 43.8 × 60.7 cm
 Bought, 1894
 The National Gallery, London (NG 1421)

HARMEN STEENWYCK (1612–1656)

18 *Still Life: An Allegory of the Vanities
 of Human Life*, about 1640
 Oil on oak, 39.2 × 50.7 cm
 Presented by Lord Savile, 1888
 The National Gallery, London (NG 1256)

JAN JANSZ. TRECK (1605/6–1652)

19 *Vanitas Still Life*, 1648
 Oil on oak, 90.5 × 78.4 cm
 Presented by Anthony N. Sturt and
 his wife Marjorie, 1991
 The National Gallery, London (NG 6533)

JACOB VAN VELSEN (about 1597–1656)

20 *A Musical Party*, 1631
 Oil on oak, 40 × 55.8 cm
 Salting Bequest, 1910
 The National Gallery, London (NG 2575)

JOHANNES VERMEER (1632–1675)

21 *The Music Lesson*, about 1662–3
 Oil on canvas, 73.3 × 64.5 cm
 Lent by Her Majesty the Queen
 (RCIN 405346)

22 *A Young Woman standing at a Virginal*,
 about 1670–2
 Oil on canvas, 51.7 × 45.2 cm
 Bought, 1892
 The National Gallery, London (NG 1383)

23 *A Young Woman seated at a Virginal*,
 about 1670–2
 Oil on canvas, 51.5 × 45.5 cm
 Salting Bequest, 1910
 The National Gallery, London (NG 2568)

24 *The Guitar Player*, about 1672
Oil on canvas, 53 × 46.3 cm
On loan from English Heritage,
The Iveagh Bequest (Kenwood)
(8802884)

25 *Young Woman seated at a Virginal*,
about 1670–2
Oil on canvas, 25.2 × 20 cm
Private collection, New York

Musical Instruments

26 Cittern, by unknown maker,
early eighteenth century, Italy.
Spruce, maple, metal, ebony, ivory
or bone, ink, pigment and gilding,
76 cm (overall length). Ashmolean
Museum, Oxford (WA1948.134)
Fig 12

27 Guitar, by René Voboam (before 1606–
before 1671), 1641, Paris. Pine or spruce,
tortoiseshell, mother-of-pearl, ivory and
ebony, 93.7 cm (overall length). Ashmolean
Museum, Oxford (WA1939.36)
Fig 11

28 Lute, by unknown maker, about 1630,
Venice. Pine, ivory and ebony,
82 cm (overall length). Victoria and
Albert Museum, London (1125-1869)
Fig 8

29 Octave Virginal, attributed to Samuel
Bidermann II (1600–around 1653),
about 1620, Augsburg. Ebony, ivory,
paper, parchment and other materials,
22 × 47.5 × 27.3 cm. Private Collection

30 Viol, by Barak Norman (before 1670 –
about 1740), 1692, London. Maple and
conifer, 118.6 cm (overall length). Royal
College of Music, London (RCM 46)
Fig 10

31 Violin, by Hendrik Jacobs (1629/30–1704),
about 1690, Amsterdam. Maple, spruce
and whalebone, 35.3 cm (body length).
On loan courtesy of the Royal Academy
of Music Museum and Collections,
London (2002.389)
Fig 9

32 Muselar Virginal, by Andreas Ruckers I
(1579–1651/3), 1633, Antwerp. Wood
and paper, 170.5 cm (overall length).
Musée des Instruments de Musique,
Brussels (1971.027)

Songbooks

33 Gerbrandt Adriaensz. Bredero, *Apollo
of Ghesangh der Musen (Apollo, or Song of
the Muses)*, Amsterdam, 1615, 15 × 20 cm.
The British Library, London
(BL 11556.bbb.67.[2.])

34 M. Campanus, J.J. Colevelts, Jan
Robbertsens and A. Pietersz. Craen,
Amsterdamsche Pegasus (Amsterdam's Pegasus),
Amsterdam, 1627, 15 × 20 cm. The British
Library, London (BL 11556.bbb.66.[1.])

35 John Playford, *Musicks Hand-maid: New
Lessons and Instructions for the Virginals or
Harpsychord*, London, 1678, bound with:
Henry Playford, *The Second Part of Musick's
Hand-maid*, London, 1689, 14 × 18.7 cm.
The British Library, London (BL K.4.b.10)

36 Jan Jansz. Starter, *Friesche Lust-Hof
(Frisian Pleasure-Garden)*, Amsterdam, 1621.
15 × 20 cm. The British Library, London
(BL 871.h.64)

37 Michiel Vlacq, *Den nieuwen verbeterden
Lust-Hof (The New Improved Pleasure-
Garden)*, Amsterdam, 1607, 15 × 20 cm.
The British Library, London
(BL 11555.ee.22)
Fig 14

The National Gallery, London, is grateful to all
lenders, public and private, for their generosity.

FURTHER READING

E. Buijsen, 'Music in the Age of Vermeer', in *Dutch Society in
the Age of Vermeer*, eds D. Haks and M.C. van der Sman,
The Hague and Zwolle 1996, pp. 106–23.

E. Buijsen, L.P. Grijp et al., *The Hoogsteder Exhibition of Music
& Painting in the Golden Age*, exh. cat., The Hague and
Antwerp 1994.

A Performer's Guide to Seventeenth-Century Music, ed. S. Carter
(revised and expanded by J. Kite-Powell), New York 1997
(revised edn Bloomington and Indianapolis 2012).

W. Franits, *Dutch Seventeenth-century Genre Painting: Its Stylistic
and Thematic Evolution*, New Haven and London 2004.

G. O'Brien, *Ruckers: A harpsichord and virginal building tradition*,
Cambridge 1990.

W. Liedtke, *Vermeer: The Complete Paintings*, Antwerp 2008.

N. Maclaren (revised by C. Brown), *National Gallery Catalogues:
The Dutch School 1600–1900*, 2 vols, London 1991.

A. Rech, 'Music in the Time of Vermeer', 2005, http://www.
essentialvermeer.com/music/music_start.html (accessed
8 June 2012).

N. Veldhorst, 'Pharmacy for the Body and Soul: Dutch
Songbooks in the Seventeenth Century', *Early Music History*,
27 (2008), pp. 217–85.

ACKNOWLEDGEMENTS

This publication, and the exhibition it accompanies, would not have been possible without the generosity and expertise of a great many people. I would like to thank my colleagues at the National Gallery for their unfailing enthusiasm and support of this project. Special thanks to Edwin Buijsen and Mimi Waitzman, who read the manuscript, corrected many errors and contributed valuable advice from very different perspectives; and to Debra Pring, for sharpening my understanding of the role of music in seventeenth-century Dutch art.

For graciously agreeing to lend precious objects in their care, and for so kindly sharing their expertise, I am enormously grateful to colleagues at the following collections and institutions: Ashmolean Museum, Oxford (Christopher Brown, Jon Whiteley); The British Library, London; Dulwich Picture Gallery, London (Xavier Bray, Ian Dejardin); English Heritage (Kenwood House) (Susan Jenkins, Anna Keay); Galerie J. Kugel Antiquaires, Paris (Valérie Sauvestre); The Leiden Gallery, New York (Laurel Dial, Dominique Suhr); Musée des Instruments de Musique, Brussels (Pascale Vandervellen, Jo Santy); The Queen's Collection, London (Jennifer Scott, Desmond Shawe-Taylor); Royal Academy of Music, London (Angela Doane, David Rattray); Royal College of Music, London (Jenny Nex); Victoria and Albert Museum, London (Max Donnelly). Finally, it gives me great pleasure to thank Ben van Benedon, Rachel Billinge, David Breitman, Andrew Fairfax, Helen Howard, Karel Moens, David Peggie, Simon Shaw-Miller, Bradley Strauchen, Graham Wells, David Winston, Allen Wright and Jolanda Zonderop for contributing to the realisation of this project with an inspiring blend of curiosity, zeal and professionalism.

This exhibition has been made possible by the provision of insurance through the Government Indemnity Scheme. The National Gallery would like to thank HM Government for providing Government Indemnity and the Department for Culture, Media and Sport and Arts Council England for arranging the indemnity.

Published to mark the exhibition

Vermeer and Music
The Art of Love and Leisure

The National Gallery, London
26th June to 8th September 2013

WITH SUPPORT FROM
The Hata Stichting Foundation

SUPPORTED BY
The Blavatnik Family Foundation
Susan and John Singer
The Embassy of the Kingdom of the Netherlands

First published in Great Britain in 2013 by
National Gallery Company Limited
St Vincent House, 30 Orange Street
London WC2H 7HH

www.nationalgallery.co.uk

ISBN 978 185709 567 8
1034693

British Library Cataloguing-in-Publication Data.
A catalogue record is available from the British Library.
Library of Congress Control Number 2012954755

Publisher Jan Green
Project Editor Claire Young
Editor Rachel Giles
Editorial Assistance Sophie Wright
Picture Researcher Suzanne Bosman
Production Jane Hyne and Penny Le Tissier
Design Philip Lewis
Printed in United Kingdom by Butler, Tanner & Dennis

National Gallery publications generate valuable revenue
for the Gallery, to ensure that future generations are able
to enjoy the paintings as we do today.

FRONT COVER Johannes Vermeer (1632–1675),
The Guitar Player, about 1672 (cat. 24, p. 68) © English Heritage
PAGE 2 Johannes Vermeer (1632–1675), detail of
A Young Woman standing at a Virginal, about 1670–2 (cat. 22, p. 65)
PAGE 4 Godfried Schalcken (1643–1706), detail of
A Woman singing and a Man with a Cittern, about 1665–70 (cat. 15, p. 53)
PAGE 7 Johannes Vermeer (1632–1675), detail of
A Young Woman seated at a Virginal, about 1670–2 (cat. 23, p. 66)
PAGE 32 Gerrit Dou (1613–1675), detail of
A Woman playing a Clavichord, about 1665 (cat. 4, p. 38)
© By Permission of the Trustees of the
Dulwich Picture Gallery, London